PARANORMAL
MIDDLESBROUGH
AND TEESSIDE

STEVE WATSON

AMBERLEY

Dedicated to Doreen Scott.
Thank you for being my Mam. I love you.

Other books by Steve Watson:

GHOSTnortheast: The Chronicles of a Ghost Hunter Volume 1
Paranormal Newcastle
Paranormal Sunderland

First published 2024

Amberley Publishing
The Hill, Stroud
Gloucestershire, GL5 4EP

www.amberley-books.com

British Library Cataloguing in Publication Data.
A catalogue record for this book is available from the British Library.

ISBN 978 1 3981 1451 7 (print)
ISBN 978 1 3981 1452 4 (ebook)

Typesetting by Hurix Digital, India.
Printed in Great Britain.

Contents

Introduction

After writing about Newcastle and Sunderland, Middlesbrough was naturally the next stop on my paranormal journey.

In the North East you grew up watching Tyne-Tees Television and as I'm a lover of football, I always looked for the Tyne-Tees, Tyne-Wear and Tees-Wear derbies as Middlesbrough makes up the big three of the North East.

I have been a regular visitor to 'The Boro' and the surrounding area of Teesside since I was a child. When I founded GHOSTnortheast, I visited many haunted areas of the county and heard many stories and reports of apparitions and activity within the towns and villages.

However, what is surprising is that Middlesbrough is a quite a new town. Calling it a town sounds a bit wrong, as due to the size and population of the place, it should have gained city status years ago.

But when you start scratching at the surface and researching its history, you find the surrounding areas are ancient and have a vast amount of history with many stories to tell.

It is thought that Middlesbrough gained its name in 686 when a small priory was built on the south banks of the River Tees at the request of St Cuthbert. The priory would be used as a resting point for monks travelling between Durham and Whitby, hence the name Middle Brough.

The priory and the monks of Middlesbrough would farm the land and take in travellers until 1537, when King Henry VIII decided to take the law into his own hands and announced the Dissolution of the Monasteries so he use the Churches' money to help finance his many wars.

We also know that the older villages and hamlets that make up today's Middlesbrough, such as Ormesby, date back to Viking times as 'by' is Norse for village or settlement.

Over the following centuries, there wasn't much happening in the Teesside area until the nineteenth century when Britain welcomed in the Industrial Revolution. This would be the start of Middlesbrough as we know it today, as the town exploded into life and became known worldwide for its industries.

Middlesbrough has the nearby town of Stockton and a gentleman called Joseph Pease to thank for its growth. Joseph Pease was a local businessman and was a major shareholder in the Darlington & Stockton Railway. He invested heavily in the coal mine of South Durham and the ironstone mines of Teesside and North Yorkshire.

However, even though he ran the railways, he found that transportation of his goods was slow and expensive. To compete with the more successful towns of Newcastle and Sunderland, he realised he needed to start transporting his products by sea. The problem he had was that Stockton was only 4 miles from the mouth of the

River Tees and the North Sea: the river was too narrow and shallow to welcome the transporter ships. Joseph decided to scout around the local riverbanks and bought the Middlesbrough estate, which at the time was being used as a farm.

Work started and the coal staithes were erected. Then in 1830, the first train ran from Stockton to Middlesbrough transporting coal to the new town, ready to be shipped around the world.

Growth was rapid as the demand for coal, steel and iron was rocketing around the world, which led to the expansion of Middlesbrough as a new port was built in 1842 to help deal with the uplift in trade.

The nineteenth century would see Middlesbrough and the surrounding Teesside area flourish and grow at an exponential rate. A new system of producing iron, called 'Bell Hopping', was invented at the Vulcan Foundry and led to Middlesbrough becoming one of the largest iron producers in the world, gaining the nickname of 'Ironopolis'. The Tees was enjoying success in coal, steel, iron and shipbuilding, along with being a hub for all sorts of imports and exports.

This success continued into the twentieth century and Middlesbrough was now affluent and had expanded as a town by absorbing the local surrounding villages. Places such as Linthorpe, Marton and Ormesby had become suburbs of the larger town.

The Second World War arrived, and Middlesbrough was heavily bombed. Hitler recognised the importance of 'Ironopolis' to the British war effort and the town suffered from over 200 bombing raids during the war years.

As the twentieth century started to come to a close, so too did the fortunes of Teesside. Iron and steel manufacturing was dwindling in Britain as people turned to cheaper sources abroad. Shipbuilding had stopped across the country, harming the whole of the North East. Then, as with the neighbouring cities of Newcastle and Sunderland, coal production stopped, and coal mines were closed. It left this record-breaking town without an industry and its people without employment.

During the 1980s and 1990s jobs were slim pickings with the only major employer in the area being the ICI chemical plant in Billingham. The town started to see a decline, which would accelerate into the beginning of the new millennium.

Hopefully, we are now seeing a change in fortune for the town as a lot of the industrial scars of the past are being removed and replaced with new factories and workplaces. Teesside is fast being recognised as a home for the manufacture of newer, greener technologies. In March 2021, it was announced that Middlesbrough would become a Freeport and hopefully this will help Middlesbrough return to its rightful place as an industrial powerhouse.

As you can see, although Middlesbrough is a young town, it has quite a history and many tales to tell. However, when you start venturing out into Teesside you find many other towns and villages with histories that go back hundreds, sometimes thousands of years. Places such as Hartlepool, Redcar, Stockton and Guisborough have become saturated in history.

During my research I enjoyed the stroll along the river that runs through the beautiful village of Great Ayton and the breathtaking views of Roseberry Topping. I loved the feeling of going back in time as I walked down the high street of Yarm

The hardest part of writing this book was fitting in as many stories as I could, from as many areas as I could cover. The stories that follow are a collection of events that I have been lucky enough to have encountered as part of GHOSTnortheast, my

paranormal investigation group, stories that I have been told over the years and stories that I have been told by the locals when visiting the various towns and villages.

No doubt some of the stories will be old wives' tales, some may have originated from too many pints on a Saturday night, and some might just be the result of an overactive imagination. I will let you decide...

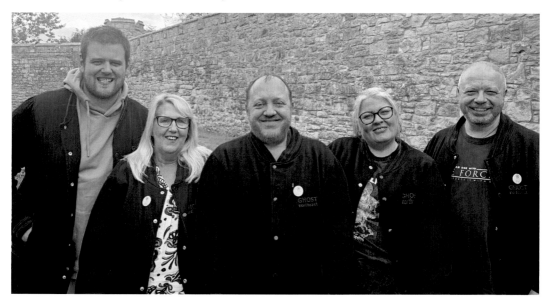

The GHOSTnortheast team with myself in the centre.

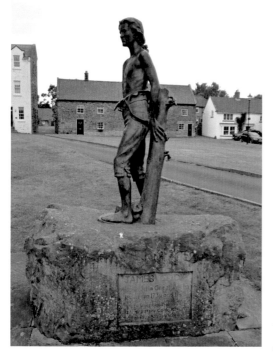

Teesside's most famous son – Captain James Cook.

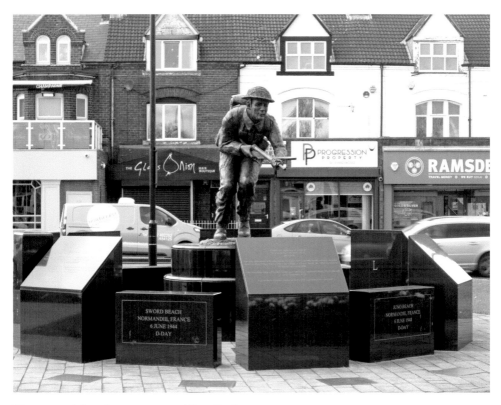

War memorial at the entrance to Albert Park.

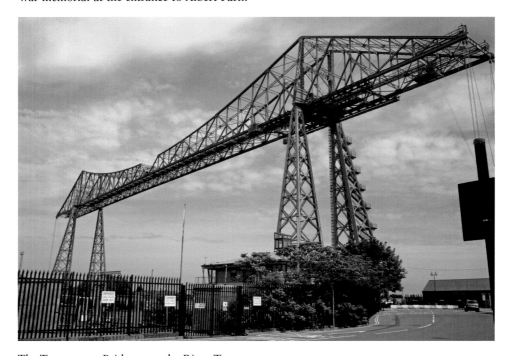

The Transporter Bridge over the River Tees.

Spooky lane alongside a graveyard.

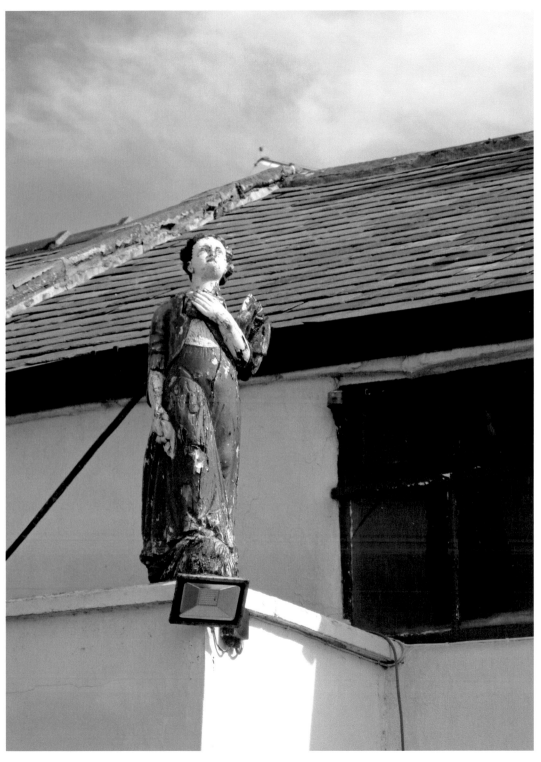

A Saltburn fisherwoman looking out to sea.

The Town Hall, Middlesbrough

When talking about ghost stories and the paranormal in Middlesbrough and Teesside, the only place you can start is Middlesbrough Town Hall.

Situated on the corner of Albert Road and Corporation Road in the older part of the town centre, the Town Hall took over six years to build, with work starting in 1883 and it opening to the public in 1889. As with all municipal buildings built in Victorian times, it was constructed with multi-purpose in mind.

One side of the building was home to the council offices, police station, cells, fire station and courtroom, whilst the other part of the site was home to an opera house and theatre to entertain the growing population of the town.

As Middlesbrough grew, so did the council and their needs started to outgrow the space available in the Town Hall. As various departments moved out to new facilities, the spaces left behind were closed off to the public and used as temporary offices and storerooms for the opera house and theatre that continued to thrive. Unfortunately, these important parts of Middlesbrough's history were forgotten.

In 2015, Middlesbrough Council announced an ambitious plan to resurrect the old building by investing in an update to the public spaces including the theatre and concert hall. They also decided to restore the historic parts of the building, creating a tourist attraction that would give the public access to the cells, courtroom and fire station. The idea was agreed, and the Town Hall closed its doors for over two years, reopening in 2018 after an investment of nearly £8 million.

I have been told many ghost stories over the years about this building but the one that stands out the most is the noise of horses being heard in the lower areas of the building. The sounds of horses' hooves clip-clopping on cobblestones and the voices of men shouting instructions never made much sense to me. Why would horses be in the middle of a building?

It was not until I saw the refurbishment of the Town Hall that I discovered it has a carriageway running through it and was a busy thoroughfare for the fire station and police station.

The police station and the cells bring us to another string of ghost stories and reported activity. Screams and sobbing is often heard in the area, along with slamming doors. The feeling of an overwhelming sadness or people becoming very emotional in this area would follow reports in other jails that I have visited across the country. The jail cells are said to be home to a sailor who committed suicide after being charged with being drunk and disorderly. He is seen wandering the corridors holding a rope.

As the building is home to a theatre, and every good theatre has a resident ghost, the Town Hall is no different. A white lady is often spotted walking around the upper floors. It is said that this is the spirit of a lady that had fallen over the balcony in

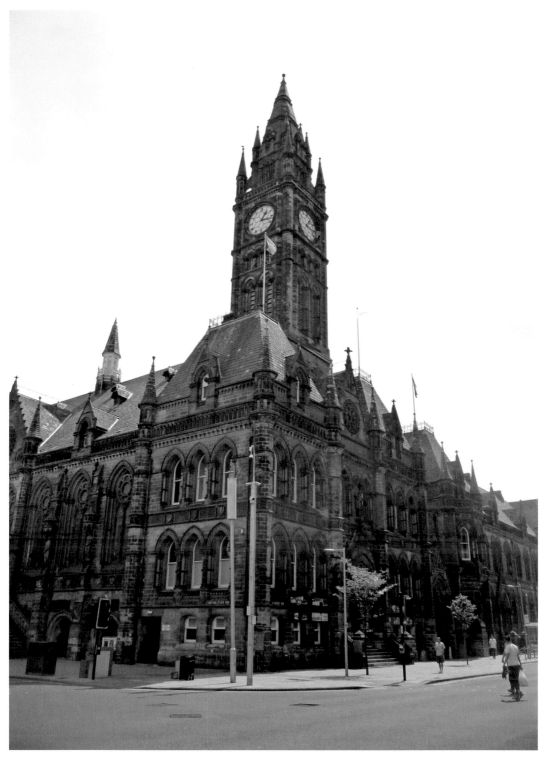

Middlesbrough Town Hall.

Victorian times, although there does not seem to be any more information to verify this story.

Another sighting is of a lady seen on the stage and in the corridors behind. She is described as being dressed like she has walked out of the 'Roaring Twenties' and seems to be celebrating something. Unfortunately, she simply disappears when she is approached. It is thought it could be the ghost of a lady called Leah Bateman. Miss Bateman was an actress and part of a group called The Macdona Players. During the 1920s when attendances were dwindling, the Opera House would be closed and converted into a cinema. She made a rally call to the local amateur dramatic societies saying,

> Keep the legitimate stage alive in your town by every means in your power. The stage is not yet dead, it is temporarily submerged by a wave of celluloid from the west. With the help of good, well-managed amateur societies the torch can be kept burning until such time as the theatre will once more take its rightful place in a society of thinking people.

It led to the joining of many of the local societies who would later build and establish Middleborough's Little Theatre down the road in Linthorpe. The ghost is thought to be that of Miss Bateman returning to the stage and celebrating that the theatre had returned to this historic building.

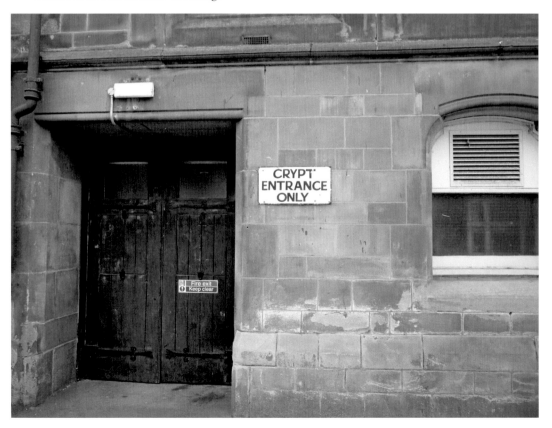

The entrance to the crypt.

Entrance to the upper floors.

Today's main entrance.

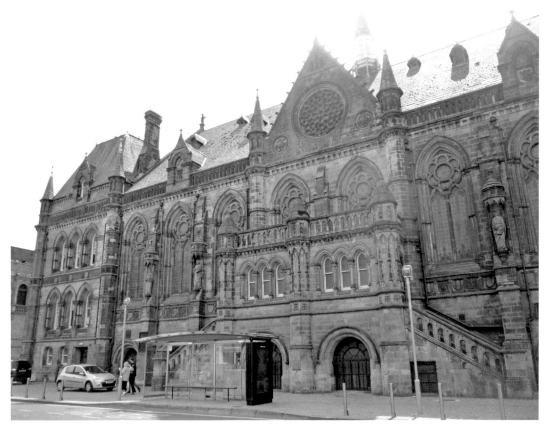

The Gothic exterior.

The Customs House, Middlesbrough

In the shadows of the famous Transporter Bridge is a building that has a very important link to Victorian Middlesbrough and is one of the original buildings that is still standing from the birth of the town's industrialisation in the nineteenth century.

The Customs House can be found on North Road on the outskirts of today's town centre. However, when it was originally built, it would have been central to the old town and its trade from the ships and trains nearby.

Built in the middle of the 1830s, the Customs House was originally opened by the Middlesbrough Exchange Association as a trade exchange, which would have mainly been coal, and a hotel for the visiting well-off gentry and businessmen.

The importance of the building is noted by the fact it was officially opened by Prince Augustus Frederick, the Duke of Sussex. Prince Augustus was the son of King George III, and his visit would be the first of any royal to the town.

In 1853, the local council bought the building and opened it as their town hall, keeping it busy until 1889 when the council moved to their new town hall which we see today on Corporate Road. After this the building reopened as the Customs House and it remained in use until the 1960s.

After the decline of industry in the area, the building remained empty until it was brought back to life ten years ago as it was converted into a community youth hub called 'MySpace' to offer a centre for the local children.

There are many ghost stories surrounding the building, many of them not making much sense when you looked at the building's layout.

A ghostly Victorian maid has often been reported walking through the downstairs corridors before vanishing through the walls. In the area people reported seeing her disappear, voices were heard behind the walls. They would say they could hear women's voices chatting, but they were quiet and muffled, like a distant radio.

But the most distinct sound reports were that of a woman sobbing. One person recalled that they had seen a young lady dressed in Victorian clothing. She had a maid's uniform on, and she simply disappeared through the wall. Moments later they could hear the clear sound of a woman crying. They put their ear to the wall and could still hear sobbing from the other side of it. They banged on the wall and shouted but no one answered. When they looked around the building the wall seemed to lead to nowhere. Similar reports date back many years, yet no one can explain who, what or why.

People also reported hearing strange noises from below ground. Men's voices and booming from below was apparently a regular occurrence. The banging was always described as heavy objects being moved around. Most people who heard these noises ended up ignoring them as they thought it must be noise travelling from the nearby factories and docks as the floor beneath was solid.

However, in 2012 with the building work underway for the new 'MySpace' project, the workmen would unearth some secrets of the building, which would all of sudden explain these ghostly goings on.

As they demolished the interior to build the new structures, they discovered parts of the building that had been blocked off decades ago. At the end of the downstairs corridor where the maid had been sighted there was a false wall that opened up a hidden passageway that led to servants' living quarters. The room is thought to date back to when the building was a hotel in the late 1800s and would have housed the staff.

If that was not surprising enough, they also uncovered a cellar. Again, the cellar had been covered for decades and wasn't showing on the building's plans. Was it used for storage back in the day or to house the casks of ale for the old hotel? It would explain all the men's voices coming from below.

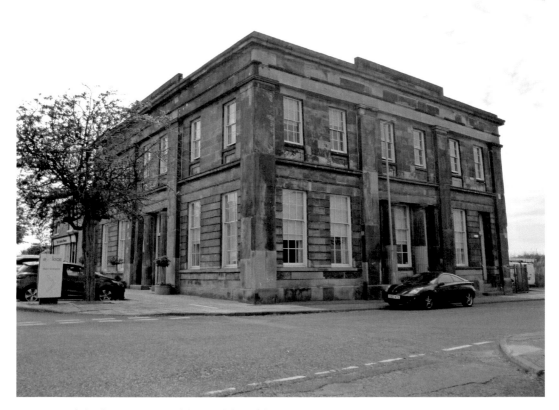

One of the few original buildings of the Old Town.

Entrance to the Customs House.

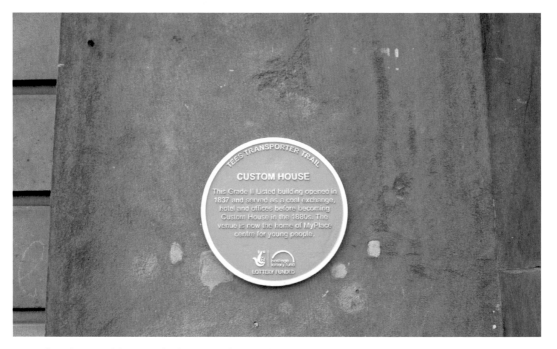

Blue plaque celebrating the heritage of the building.

Swatters Carr, Middlesbrough

Situated on the busy Linthorpe Road, Swatters Carr is today owned by the Wetherspoons pub chain after they refurbished the building in 2011. However, if you scratch away at the name and the history of the building it has quite a past.

A farm stood on the land and can be seen on a map dating back to 1618. The farmstead was called Swatters Carr. The farm would function until the nineteenth century when the land was bought and then built upon at the start of the creation of modern-day Middlesbrough.

The building we see today was constructed in 1878 during the modernisation period of the town and the three-storey Victorian pub opened as 'The Swatters Carr Hotel'. At the turn of the century the hotel changed hands and its name was changed to The Empire Hotel. In the early 1900s it was owned by the Bach family. Mary Bach would become the proprietor in 1910 and her brother Philip would eventually move into The Empire.

Philip Bach would become a well-known figure for Middlesbrough football supporters. Phil started his footballing career at Middlesbrough FC before moving to Reading, local rivals Sunderland, Bristol City and finishing his playing career at Cheltenham Town. His proudest moment must have been his debut and only cap for England in 1899.

After moving into the hotel, he returned to Middlesbrough FC and in February 1911 became a director of the club. In July of the same year, he was appointed as chairman. He would become one of the most successful chairmen as he appointed Thomas McIntosh as the club's manager. Together they rebuilt the club and in 1913 they guided it to third place in the First Division (today's Premiership). This would be the highest finish for the club and still stands today. Philip died in Middlesbrough in 1937 and The Empire Hotel was said to have seen many a footballing meeting take place in the back area of the bar.

The hotel would scale down over the war years and it became a pub rather than a hotel with many names over the following decades. It would be known as The House, The Hog's Head and The Tavern before Wetherspoons finally returned it to its original name.

The ghosts of Swatters Carr all seem to be angry. Reports of poltergeist activity across all three floors are rife, with tables and chairs being moved around violently. Doors open and slam shut when there is no one on the floors above, never mind in the rooms. Staff over the years have reported not wanting to visit the third floor by themselves. No one seems to have an explanation as to who or why there would be such an angry spirit still roaming the floors.

The paranormal activity on the ground floor is the complete opposite. Staff have reported hearing men talking in the back area of the pub when the pub is closed and empty. It is reported to sound like a radio playing in the distance, muffled and too quiet to make out the words being said. Coincidentally it is reported to be more often heard after Middlesbrough have played a match. I would love to think it's Phil Bach and friends still around watching and discussing the football. And who knows, if anyone ever gets a sound recording, hopefully they are saying 'Up the Boro!'

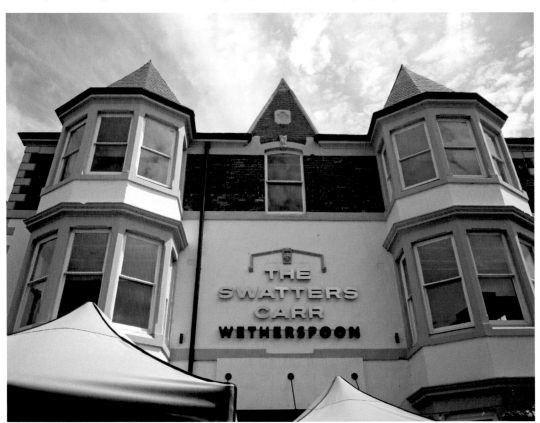

Outside view of Swatters Carr.

4

Acklam Hall, Middlesbrough

Acklam is one of the oldest parts of Middlesbrough and like many parts of the modern town, it started as its own hamlet. Thought to originally be an Anglo-Saxon settlement, it is first mentioned in the Domesday Book in 1086 as the manor of 'Aclun', meaning a place of oaks.

The land swapped hands many times over the next few centuries before finally the whole estate was bought in 1637 by a Bridlington cloth merchant called William Hustler. The estate would then stay within the Hustler family until the twentieth century. It would be William Hustler's grandson, also named William, who would build the hall that we see now. William Hustler II would be knighted and become known as Sir William Hustler and in 1683 he commissioned a hall to be built in the middle of his estate.

The hall was built with grandeur in mind and is in keeping with the time period, with fine detail made to the ornate ceilings. Much of what we see today is the original building and luckily a lot of the decorative architecture is still intact.

Sir William would live the rest of his live in Acklam Hall with his wife Anne. They would go on to have thirteen children but unfortunately only four would live into their adult years.

For the next 200 years the estate would be handed down through the generations. One notable relative was Thomas Hustler, who was born in the USA. He would become a historical figure as he helped foster Middlesbrough's emergence as an industrial powerhouse in the mid-nineteenth century. In 1928, the Hustler family no longer resided at Acklam Hall and the land was bought by the Middlesborough Corporation for £11,500.

In 1935, the Corporation redesigned the building as a school and it opened as Acklam Hall School for Boys. In 1958, it became known as Acklam Hall School before finally, in 1968, becoming Acklam Hall High School.

In the 1970s it would change its name again after the school had been expanded with school buildings erected on the once beautiful gardens. The hall would be known as Kings Manor and Acklam Sixth Form College.

The building enjoyed its new lease of life until 1995 when tragedy stuck, and fire burnt through the newer school buildings, leaving them gutted and in need of being demolished. The hall was left unharmed and continued to be used by Middlesbrough College until 2008 when the building became vacant.

Restoration began to bring the hall back to its former glory and in 2016 it was sold to its new owners who have transformed this beautiful Grade I listed building into an events venue complete with a restaurant.

Over the years I have literally heard hundreds of ghost stories about the hall and its surrounding area of Acklam. I was told about the Devil's Bridge that's just a few minutes' walk from Acklam Hall where the becks of Marton West and Newham meet.

The proper name is Newham Bridge and over the years it has been reported that the hoof print of Beelzebub himself can be seen underneath the bridge and it was where the Devil would meet the workers and locals in the eighteenth and nineteenth centuries to make deals of riches in exchange for their eternal souls. There is no historical reason for these stories other than they were old wives' tales to keep the children awake at night. However, I must admit I have never had the bravery to cross the bridge late at night to test the story.

Another story that I was told by a gentleman who was reminiscing about his youth when he grew up around Acklam Hall echoed well-known stories about the dogs of the hall. He said that he was cutting through the hall's grounds with a friend when they came across a pair of white dogs. He described them as being medium-sized beagles. He said they were growling at them but there was no noise. He even said that he knew that this statement made no sense, but he knew they were growling. He and his friend turned on their heels and started running back out of the grounds terrified as they could hear the dogs chasing them.

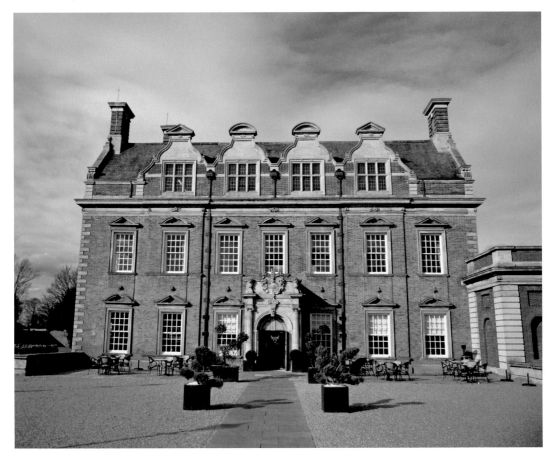

Acklam Hall.

As they jumped the fence and stood outside of the grounds, the dogs disappeared. It wasn't until later research that he found that Acklam Hall has many references to Talbot dogs. However, this happened in 1950s and the Talbot has been extinct since the nineteenth century.

In the hall itself every room seems to have a story. Period-dressed children are often spotted running around its hallways. The crying of babies is heard coming from the upstairs rooms. But the most well-known ghost is that of the Grey Lady. Over the years the Grey Lady has been seen all around the hall, both inside and out. She has been seen looking out of the windows, but she is most often spotted on the main staircase.

People describe her as wearing a flowing dress and usually sobbing before disappearing in front of your eyes. Some say that the woman simply slipped and fell to her death on the stairs, although others say she died after childbirth. Whichever is true, most believe that it is the spirit of Charlotte Hustler, the wife of William, and she still wanders around her former home.

Story plaques of the hall.

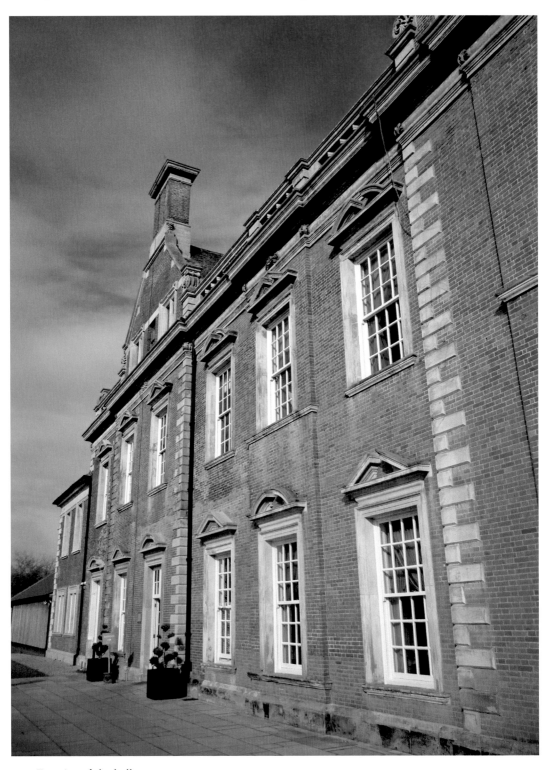

Exterior of the hall.

The Central Library, Middlesbrough

Middlesbrough town centre is full of ghost stories. However, some of them are just short stories with not a lot of history to them.

There's reports of a soaking wet small boy that sits and cries in the centre of Captain Cooks Square. It is reported that he is the unfortunate soul who drowned in the public swimming pool that once stood there.

The Crown, which is a large empty pub on Linthorpe Road, is said to be the home of numerous spirits including an angry man and a little girl.

There are the stories of monks, complete with their dark habits, walking along the street and through the houses and shops in Priory Place. This, of course, would make sense as the priory stood there between 1119 to 1539.

However, what interested me were the tales of the paranormal goings on at the Central Library, which is in the centre of town and stands on the edge of Victoria Square. It opened in 1912 and has been lending books to the folks of Teesside for over a century. The original cost of £15,000 was donated to the town by philanthropist Andrew Carnegie.

Carnegie had no links to Middlesbrough apart from the coincidence he made his fortune in steel. He was known for his donations to build libraries across the world as he believed everyone had the right to read. Middlesbrough's Central Library, like many others, was often referred to as the Carnegie Library.

There is no other history to the building as it has been a library all of its life, but it has a good few ghost stories attached. Reports of children being heard in the old children's section, books being moved and falling from the shelves and distinct sounds of pages being turned when there is no one in the room at the time have been relayed for decades. However, it has a 'Ghost Room'.

The Ghost Room is on the upper floor and received its unusual name from the staff of the library. They reported being touched in the room and hearing breathing close to them when the room was clearly empty. They have reported the door opening and closing on its own. The Ghost Room was mentioned in 2008 on BBC Tees as a group of children had taken part in a fun ghost hunt with the staff and at the end of the night, they had a very unusual photograph of a dark figure in the corridor.

Who still visits the room in Central Library is still unknown.

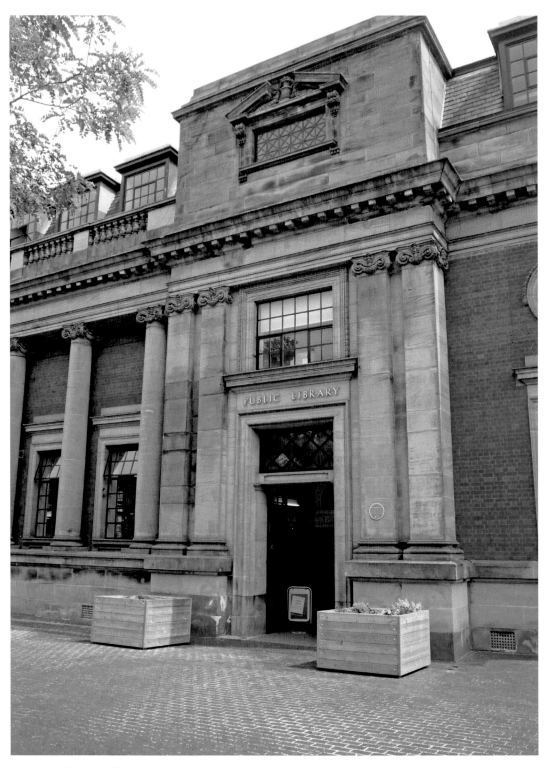

Outside of the library.

The Yorkshire Room.

The original fixtures and fittings.

The old children's entrance.

Dorman Museum, Middlesbrough

Sitting on the edge of Albert Park in the Linthorpe area of Middlesbrough is a building that would become one of the town's landmarks. The Dorman Museum was opened in 1904 and was given to the town by Sir Arthur Dorman as a memorial to his son, who he lost during the South African Wars at the end of the nineteenth century.

Sir Arthur was born in Kent before living in London. He moved to Teesside in 1870 to work with relatives in the growing ironworks that were becoming successful around Middlesbrough. Aged twenty-seven, he went into partnership with another local steelworker called Albert Long and together they bought the local West Marsh Ironworks. Within a few years the company of 'Dorman Long' became known worldwide and the two young owners were recognised as important industrialists and their company became a major employer to the new town of Middlesbrough. The Dorman Long Company would go on to build Newcastle's Tyne Bridge and the Sydney Harbour Bridge. Sir Arthur would spend the rest of his life serving the town before passing away at Grey Towers in Nunthorpe aged eighty-two.

The museum has become a centrepiece for the history and culture of Middlesbrough and its surrounding areas. Its two floors house a number of displays and exhibitions. There are sections for natural science, ancient artefacts that were found on digs in the nearby Eston Hills and a large display of items from the local Linthorpe Pottery. What I found interesting about the museum was its tranquil atmosphere. It's easy to forget you are on a busy main road.

Paranormal reports within the museum all seem to centre around two men. Footsteps are heard on the upper-floor corridors when there is nobody in the area. Jangling keys are heard in the same area. Open doors are shut with no help from draughts or any natural explanation. These happenings are always in the early evening when the museum is closing or first thing in the morning before opening. It is believed to be a former curator still walking the museum to make sure everything is in its place for the visiting public.

A man has also been spotted mainly in the Henry's Room and the entrance near to the tearooms. He is described as a very well-dressed gentleman in a three-piece suit and tie. He has grey hair and wears round-rimmed glasses. He has also been seen wearing a top hat at times.

It is said to be the ghost of Sir Arthur Dorman himself as he still visits the museum that he was so fond of in life.

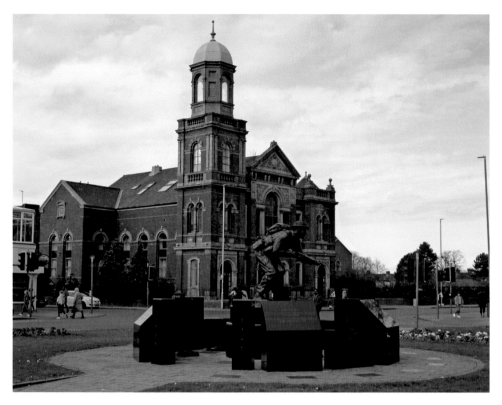

The Dorman Museum.

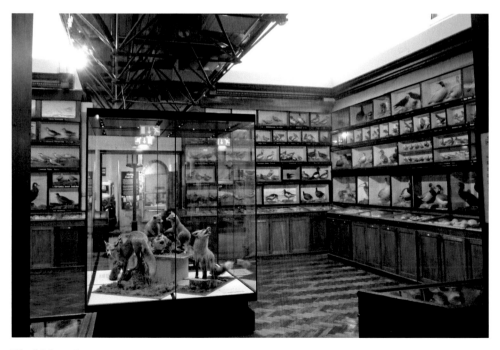

The Nelson Room.

Upper corridor where footsteps are heard.

The Town in Time exhibition.

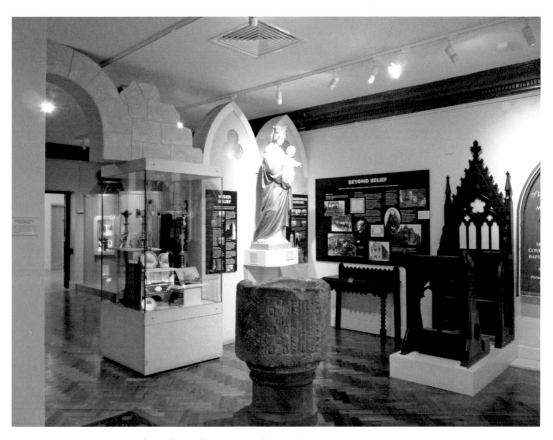

Some important artefacts from the town's religious history.

The Lost Village of East Marton, Middlesbrough

I have heard many ghost stories about Stewart Park in the Marton area of Middlesborough but never understood why this area would have been so active until I delved into its history and things began to make sense.

Marton, not far from of the town centre, is probably better known for being the birthplace of Middlesbrough's most famous son – 'Captain James Cook'. The large hospital on Marton Road is named after him and at the top of the road is the impressive Stewart Park. It's within this park that things become interesting, and the ghost stories begin.

Stewart Park is an impressive and expansive 120-acre public park that was first opened to the public in 1928. It boasts wooded areas, lakes, ponds, a play park and hosts numerous events throughout the year. In the park, you will find the Captain Cook's Birthplace Museum. The museum was opened in 1978 to celebrate the famous explorer. Near to the museum you will also find the Askham Bryan College, which is a Victorian farmstead that has been converted into a modern, state-of-the-art educational centre.

By looking at the buildings that are still standing in the park you get an idea of the history of the surrounding area, but when you dig beneath the surface, you find a history dating back to medieval times.

In the twelfth to eighteenth centuries Marton was split into two villages, East and West. East Marton was at the south side of today's Stewart Park and was the birthplace of Captain Cook. However, after an archaeology and research project at the beginning of this century, it became clear that East Marton was a bigger settlement than first thought and the village had stood for a good few hundred years longer than originally thought. It is believed that the village had many houses, a blacksmith, an inn, and its very own small church.

For reasons unknown, the village would start to empty in the 1770s, the same decade as its most famous son was discovering Australia. The buildings soon became ruinous and in 1786 the Marton estate was bought by Bartholomew Rudd. Rudd demolished the village and flattened every building to make way for his new family home of Marton Lodge. The village of East Marton would be lost forever as the area became known as Marton.

The history of East Marton could be the source of apparitions that have been seen in the area as some of the stories are of a little boy and a little girl seen around Stewart Park small pond. The small pond is near to Captain Cook's Museum and is the area where the village would have been.

The boy and girl are seen playing together but witnesses say they are surprised by how they look. They are dressed in rags and look dirty. They are often described as looking like something out of *Oliver Twist!* The children don't interact with anyone and it's not until they seem to float across the pond that anyone takes any notice.

I was told by a local lady that she was sitting on the park bench next to the pond eating her lunch as it was a warm summer's day. She said it was very quiet, and she was the only person there when she noticed two children playing at the side of the lake. She didn't see where they came from and was surprised that they hadn't made a sound. She said that she had started watching them as she was worried that they may fall into the pond and became curious by the way they were dressed. Their hair was unkempt and they looked like they needed a good wash. She described the boy as being in a raggedy old grey shirt and shorts and the girl had a pinafore dress that was once probably white but now was a dirty shade of grey. Both looked like the street urchins seen in medieval London.

Then all of a sudden, the girl ran away from the boy and the boy gave chase and it was at that point that the lady felt afraid. She said that it looked like the children were playing a game, but it was unusual as they still had made no sound. No laughing or shouting. No talking at all. Then the girl ran across the pond. The lady said she felt her jaw drop open as she couldn't believe her eyes. This was then followed by the boy running across the pond after her before both of them disappeared into the trees. She said that she sat there for a good five minutes trying to understand what she had seen before getting up and walking to the trees where they had disappeared. She told me,

> I honestly thought I was losing my mind or hallucinating. I could not get my brain to except that they had just ran across a pond. The whole scenario that had just played out in front of me was the strangest and scariest experience I have ever encountered.
>
> When I tell people the story, they laugh or raise their eyebrows as if I am mad or making it up. But you know what? I know what I saw that day and if no-one believes me so be it.
>
> I have never returned to the pond ever since, although I never felt like I was in danger, I just don't want to see anything like that again.

The lady's story does coincide with other sightings of ghostly children near to the pond. Could these be the children of the lost village of East Marton?

Continuing with the history of Stewart Park, Marton Lodge had been built and would be the home of the Rudd family until 1832 when the lodge burnt down. It was completely gutted by the fire and the remains of the building had to be demolished and the land lay empty.

The estate was then bought twenty years later by a local industrialist called Henry Bolckow. He constructed Marton Hall on the land where the previous lodge had stood. He also built a large farm and stables nearby. Bolckow died in 1878 and as he had never married and had no children, the estate was bequeathed to his nephew Carl Bolckow. Carl and his family never lived in the hall, and it deteriorated over the decades as its only use was to house a handful of soldiers during the First World War.

In 1924, local philanthropist Thomas Dorman Stewart bought the parkland estate. In 1928, he opened Stewart Park and gifted it to the people of Middlesbrough.

As the park flourished, unfortunately the hall continued to decay and in 1959 the decision was made to demolish the ruinous hall. Coincidentally before the work was finished, the hall caught fire in 1960 and burnt to the ground in the same way as Marton Lodge had 128 years earlier.

The farmstead and stables survived. The original Victorian stables and main buildings are today used by Askham Bryan College. The college had its fair share of reports of paranormal activity. There are reports of horses being heard in the area.

However, it is the large building in the middle of the campus that has had the most activity. The Central Lodge is an impressive Victorian building that stands opposite the stables and today is used as a visitor centre and café.

Sightings of maids dressed in Victorian clothing and young men dressed in Victorian hunting gear have been reported many times. Faces have been seen looking out of the upper-floor windows when the building has been closed and there is no one inside. All these reports make sense as the building housed the staff to the nearby Marton Hall.

Stewart Park is a beautiful place to visit and is full of things to do and see. But you never know, the next time you visit you might get a glimpse into the past without even having to visit the museum.

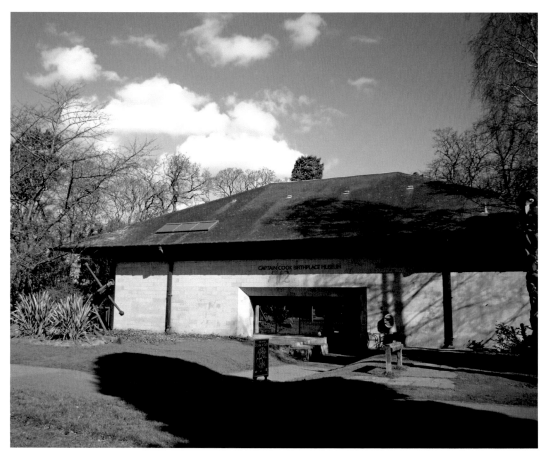

The Captain Cook Museum.

Stewart Park.

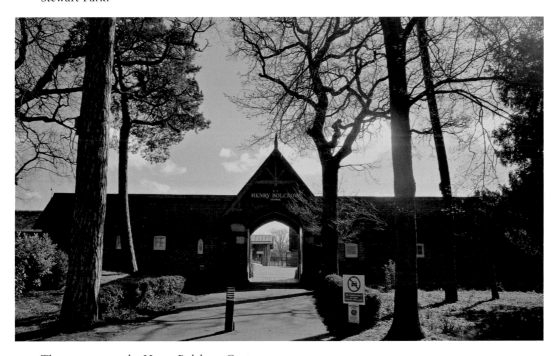

The entrance to the Henry Bolckow Centre.

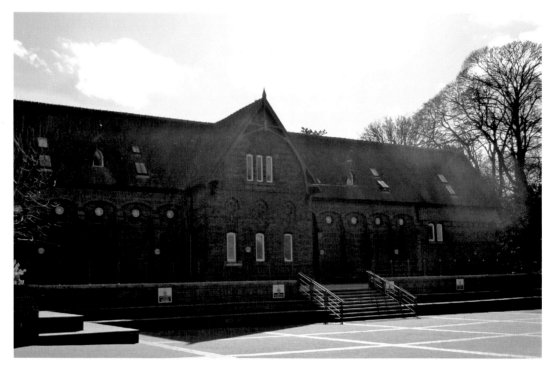

The Central Lodge where apparitions have been seen.

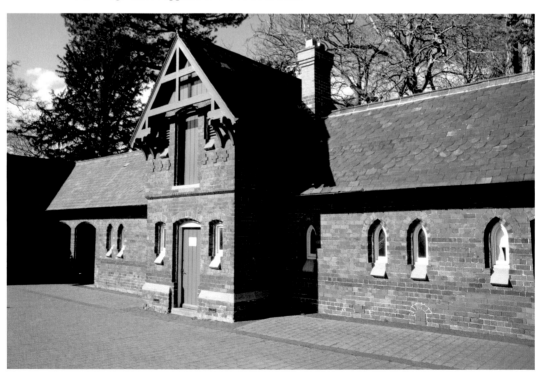

The original stables where the sounds of horses are reported.

Ormesby Hall, Middlesbrough

Another well-known hall in Middlesbrough is at Ormesby, about 3 miles south of the town centre. Ormesby is another village that has a history of over a millennia; it's mentioned in the Domesday Book of the eleventh century as land owned by 'Orems'.

The Ormesby estate was a vast one during the Middle Ages as it stretched all the way to the banks of the Tees and was mostly farmland. The village itself would have been exactly where it is now and grew as the centuries went by. We know from the Hearth Tax of 1673 that there were at least twenty-four houses as the estate was owned by James Pennyman who had bought Ormesby from the Strangways family.

The Pennyman family would become important to the village we see today as his descendants would live in Ormesby until 1983, when the National Trust started to care for this luxurious manor house.

Ormesby Hall stands where the original manor house stood, which was built by James Pennyman in the 1600s, although what we see now was rebuilt in the middle of eighteenth century by another James and his wife Dorothy. The work was completed in the 1750s and does incorporate some of the earlier hall.

The Pennymans owned the estate for over 400 years and what makes the research into the ghost stories difficult is that nearly all of the men were called James. Probably the most well-known was nicknamed 'Wicked Sir James'. Again, there is not a lot of information as to why he was named wicked. He did have a serious gambling problem and was known for his extravagant lifestyle. Whether this made his temperament rather fiery due to the constant stress of his situation is only for history to know. But we do know he was forced to sell a lot of his estate and belongings, including the furniture and fittings of the hall, to pay off his debts before moving away from Ormesby.

It is believed Wicked Sir James still roams the rooms and corridors of his hall. He is believed to still be an angry soul that bangs and slams doors and pushes past visitors. These visitors describe standing looking around the rooms and feeling like someone has pushed past them rather rudely, but no one is there.

Another ghost story I was told took place in the stables area. In the 1800s a young stable boy was going about his daily jobs and caring for the horses when one of them became spooked and kicked out. The boy was in the wrong place at the wrong time and took the horse's hoof straight to the head, dying on the spot. I must say at this point I couldn't find any information in the history books about this incident but to be fair, it probably wouldn't have been reported.

I was told by a local gent that he had spotted the stable boy on a visit to the hall. He recounted that it was during the day, and he had seen a young boy in his teens dressed in old-fashioned breeches and a white cloth shirt. He was walking around the empty

stables but seemed to be doing chores. At this point the gentleman had started walking closer to see what the boy was up to, when the boy turned and walked straight through a wall. The gentleman told me that he instantly froze to the spot, staring at where the boy had disappeared. When the initial fear had worn off, he walked around the building but could not find the boy again. He said, 'And that was the day I began believing in ghosts'.

The most well-known ghost story of the hall, as there has been many reports, is that of a sobbing maid. People have reported hearing the crying and sobbing of a lady coming from the old washroom, but when they go into the room to investigate there is nobody around. There has also been reports of a young lady dressed as a maid from the olden days sat crying in the corner of the room, only to disappear as someone approaches. Other reports are of people feeling very sad and emotional in the area with no explanation. Could this be the spirit of one of the housemaids? The story goes that during the eighteenth century a housemaid fell in love with the lord of the manor and started an affair. Knowing the history of the Pennymann family it is probably safe to say he was called James. The affair continued until the maid fell pregnant. When she told her lover he became enraged as it would bring scandal to his family, and he attacked the young lady. She fell and banged her head on the stone floor of the washroom and died from her injuries along with her unborn child. Some people say she died there on the cold floor of the washroom and her body was moved and the whole incident covered up to save the lord's reputation. Some say she managed to flee the clutches of her angry lover but died later in her home. Either way it is thought the sobbing maid is searching for her unborn baby.

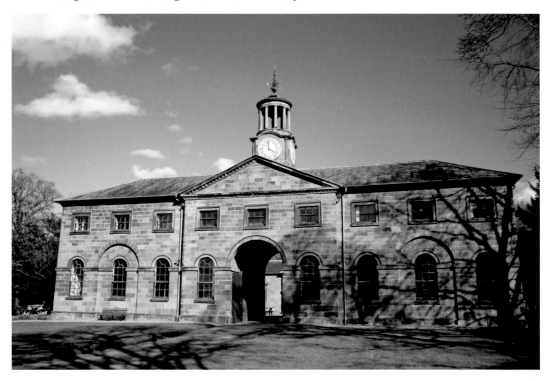

Ormesby Hall.

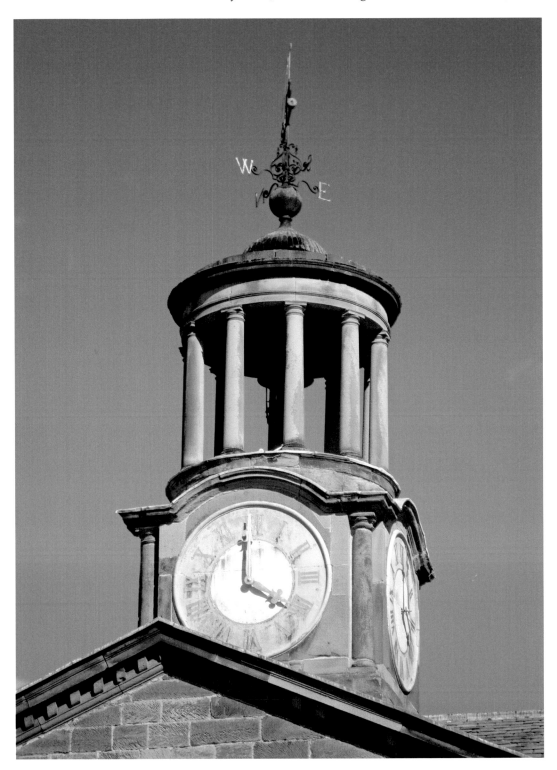

The clock tower.

The landscape outside of the hall.

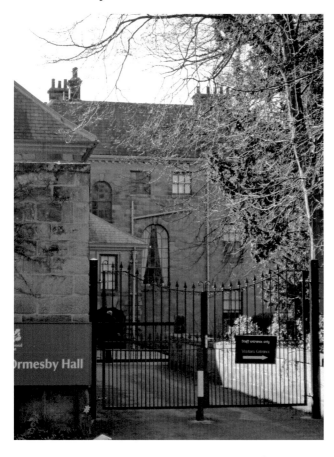

The original buildings.

The Heugh Battery Museum, Hartlepool

Hartlepool has a long and fascinating history that dates back to prehistoric times. It is believed that the headlands area where the museum now sits was an island covered in a forest. During an excavation, tree stumps were found in the ground along with antlers and teeth from deer. The forest can be traced back to the thirteenth century when the area was named 'Heret Eu' meaning 'Stag Island'.

The area we are concentrating on is 'The Headlands', which was also known as Old Hartlepool. The town was once two towns, named Old Hartlepool and West Hartlepool, but they became the one town we now know in 1967.

The headland, or heugh, houses the lighthouse and the Heugh Gun Battery Museum. The first gun batteries were built during the Napoleonic Wars and the Heugh was built alongside the Lighthouse Battery and Fairy Cove.

The newer Heugh Battery was built in 1859 and was more substantial than its sister sites. The work started to fill in the caves in the coastline below, and over the following years its guns and equipment were upgraded with bigger and better technologies.

In 1893, during quieter times, the battery was downgraded to a volunteer post used for observation and training purposes. However, six years later in 1899 the post was reactivated with the installation of two new 6-inch Mark VII costal defence guns, although there is no official reason why this was done.

It would be at 8.10 a.m. on 16 December 1914 that Hartlepool's Heugh Gun Battery was to establish its place in the history books. Three German gun boats started an hour-long bombardment on Hartlepool, which was seen as a prime target due to its shipbuilding port. During the hour many of Hartlepool's seafront buildings were hit, causing many casualties and deaths. The Heugh began firing and its guns became the only mainland guns to be shot in anger during the First World War. Unfortunately, one soldier was killed during the bombardment and was to become the first British soldier to be killed on home shores during the war. A plaque is in place today near the Heugh.

The Heugh took little part during the Second World War, but its guns were changed in 1942 when, during the Battle of Britain, it became an air and sea defence site.

The Heugh then became a training site after the war and was to be closed in 1956 when the guns were finally removed. The site lay in ruin until 2000 when a local group of volunteers banded together and set up the Heugh Battery Trust. Their aim is to keep the historic site intact to remind us of the importance of our sea defences. Over the past two decades the trust has done a fantastic job in restoring the original

features, including two of the gun emplacements, an underground magazine, the original barracks, and the Command Post on top of the hill. The Parade Ground is peppered with new and old military vehicles and guns including tanks, armoured cars, and mobile cannon.

The museum is home to many ghost stories, and I have been lucky enough to spend some very cold nights in various parts of the site. The two places that I can talk about from personal experience are the Underground Magazine/Bunker and on the parade grounds between the buildings which is currently home to the numerous military vehicles.

On one of my visits, I was walking from the café to the underground bunker when I heard a whistle. It was loud, clear and came from behind the armored car. I immediately thought it was one of the GHOSTnortheast team who were on site with me conducting an overnight investigation. As I walked around the corner there was no one there. I radioed the team and they were all in the lookout tower on the other side of the site.

To be honest I shrugged it off and moved on. As I moved away from the vehicle, I heard the whistle again, only this time it felt as if it was right behind me. I turned around and again there was no one to be seen. I called for one of the team to join me and told him what had happened.

We returned to the café and retraced my footsteps. As we approached the area, we both heard a voice say 'Halt'. We stopped still immediately and looked at each other; we both said it came from the armoured vehicle, yet we knew nobody else was on site. Again, we started to walk away towards the magazine and we both heard a loud whistle.

The gun of the Heugh's name.

Part of the
underground
shelter.

I have no explanation for where these noises came from or who had made them. However, I have been told by some members of the staff that it is a regular occurrence and has been reported by other visitors.

The other area I can share my personal experience from is the Underground Magazine located on the edge of the museum. During my visits I have recorded a series of unexplained noises including footsteps, knocks and bangs. I've also recorded a number of strange light anomalies that I can't explain as the usual reflections or insects.

However, the most frightening sight in this area was when I was under the ground with a group of guests, and we saw a large figure at the end of the corridor. At first, we thought it was a member of the group and asked them to return to where we were standing. When it didn't respond and we looked around, we realised that everyone was present. As I walked up the corridor with my camera the figure moved off around the corner and as you probably guessed, it disappeared from sight.

These are just a couple of examples I can give of my personal experiences. But the Heugh has its own stories, including of a soldier dressed in First World War uniform in the area where he was killed. There have been lots of reports of people being pushed and shoved on the site and it's believed to be the spirit of an angry sergeant that does not like people getting in his way.

The strangest tale that has been reported numerous times is of a little girl hunched over and sobbing in the barracks, which is currently the entrance to the museum. When you approach the girl, she turns around and is burnt and disfigured. She then runs out of the building and can't be found. Could she be the spirit of one of the 113 poor souls who lost their lives during the German attacks in 1914?

Armoured car where we experienced activity.

The Rat Run where there were many reports of footsteps.

Signpost
in the
underground
shelter.

The Monks of Castle Dyke Wynd, Yarm

Yarm is a small market town on the banks of the Tees approximately 8 miles east from Middlesbrough. Its unique location places it where the river creates a natural horseshoe, leaving the town surrounded by the river on three sides. The town is thought to date back as far as Viking times as the world-famous 'Viking Helmet' was found in the 1950s by local workmen. It is believed to be one of only its type found in the world and has taken pride of place in the nearby Preston Park Museum.

We can see that the town, with its name meaning 'a pool for catching fish', was starting to flourish during medieval times and is mentioned in the Domesday Book. During the 1200s, a friary was built by Dominican monks and the monks would provide for the locals by building a hospital, and would have provided spiritual guidance. The friary stood proud near to the river until Henry VIII decided to establish the Church of England in 1536 and all the friaries, priories and monasteries in England were to be destroyed, burnt to the ground, or occupied by his people and soldiers.

The area where the friary once stood is now known as The Friarage, which was built in 1770 by the Meynell family. The local family built the house on top of the cellars of the original friary. The building is now part of Yarm School.

Moving through the ages, Yarm became recognised as a bustling market town and also became well known for its annual fair that would take place up and down the High Street, which would include horse racing.

Modern-day Yarm has kept much of its historic character. The cobbled paths are flanked by buildings that were built in the late 1700s and early 1800s. The original tollbooth still stands proud in the centre of the town complete with its clock tower.

With a town with so much history, it comes as no surprise that it has its fair share of ghost stories. There are tales of a ghostly couple who died in the river when they arranged a secret rendezvous as their love for each other was forbidden. It's said that they decided to end their lives together by jumping into the river and their spirits are still seen hand in hand on the riverbank.

There are stories of soldiers seen around and on the bridge that crosses the Tees. It is the area where a large fight broke out during the Civil War. In 1643, a group of Parliamentarians decided to try and ambush a group of Royalists that were transporting weapons and supplies to their soldiers in Yorkshire. A skirmish broke out; however, the Parliamentarians were quickly defeated and killed. Are the figures that are spotted in this area the spirits of the defeated soldiers?

The Black Bull pub.

Inside the Black Bull, where a monk has been sighted.

The beer garden where a
monk is seen hiding.

Over the years there have been many sightings of monks, mainly around the High
Street area and down the connecting wynds. However, I'm going to concentrate on
one story that I was told by an elderly gentleman who had worked in the Black Bull
pub in the 1980s. Although his memory had gaps in it, the stories he told me were
still vivid.

The Black Bull is situated in the middle of the High Street near to the old tollbooth.
The back of the pub and its enormous pub garden runs down to a small lane called
Castle Dyke Wynd on the banks of the river. The building is of fine Georgian design,
and we do know the pub has been there as far back as 1890 at the earliest and was
owned by a local brewery called Bulmer & Co., which owned many of the pubs in
Yarm at the turn of the twentieth century.

The gentleman told me that he worked there for a number of years and a monk
had been seen many times in the pub. He said that the figure was quite tall and
looked like it was wearing black hooded robes. This would match the history as the
Dominicans were known as the Blackfiars. The monk had been seen by quite a few
people over the years and became known as 'The Shy Monk', due to the fact that
every time he was spotted, he would disappear around a corner or an object as if he
was trying to hide.

The old street signs of Yarm.

More old street signs.

The barman told me that no one seemed frightened by the apparition after the initial shock of seeing it. He said that he had seen it a few times over the years and always felt as if it was more frightened of him than him being frightened by it. He continued:

You would catch movement out the corner of your eye and look around. You would then see this figure dart behind something, whether it be the bar, cupboard or through a door, but when you walked across to where you had seen it, it would be gone. Once when I was in the cellar, he seemed to duck behind the casks and barrels which made me laugh as he would have to be lying face down on the floor and it's cold in there.

The monk has not just been spotted in the pub. There are reports of him darting about the gardens at the back of the building and on the Wynd near the river. Again, it is said that once you have seen him, he darts away behind a tree or the bushes. The original path from the friary to the bridge would have been in the area that the apparition is spotted. Could this be the spirit of a monk escaping from Henry VIII's men when his forces visited Yarm during the Dissolution of the Monasteries? It would explain why he hides when he is spotted.

The Ghost with a Silver Nose, Yarm

Another ghost that is spotted in the picturesque market town of Yarm has not just been seen up and down the High Street but also in the graveyard of St Mary Magdalene's Church.

Reports are that a man is seen dressed in an eighteenth-century soldier's uniform, bright red in colour with black breeches, and he wears a hat. Some say they can see a sword hanging from his belt. Then they describe the most unusual feature of the ghost. He has a silver nose! He is often seen walking the High Street late at night before disappearing into the walls of one of the houses. When he is spotted in the graveyard, he seems to be happy with his head bowed towards one of the tombstones. Could this be the spirit of one of Yarm's most famous sons, Thomas Brown?

Thomas Brown was a young shoemaker's apprentice in Yarm before deciding to join the Army. He swore his Oath of Alliance to King George II and became a dragoon. He was sent to southern Germany in 1743 to fight against the French during the War of the Austrian Succession.

On 27 June 1743, Thomas was one of the English soldiers that took part in the Battle of Dettingen. The battle was hard, and the French had killed half of the British men and they now had the upper hand as they strongly outnumbered their British counterparts. As the British troops retreated, Thomas had seen the soldier holding the regiment standard had been wounded and the flag had fallen to the ground. Knowing how important the flag was, he quickly jumped off his horse to gather it.

As he picked up the flag, he was attacked by a French soldier, who stabbed him in his hand and stole the flag from him. After gathering his thoughts through the pain of his wound, he saw the Frenchman on a horse. He dismounted the Frenchman and killed him before jumping on the horse. With the flag in his possession, he raced through the French troops at pace towards his own men. As he ran the gauntlet across the field, he was attacked numerous times and received two musket shots to the back, and it is said his hat had numerous holes from the gunshots. As if this was not enough for most men, Thomas was cut several times across his legs, body, and face. One of these cuts severed part of his nose.

As he finally met with his own men, he was greeted with applause and cheers as the soldiers had watched this young man's bravery. Thankfully he recovered from his injuries, and it is said that King George II himself presented Thomas with a pension, a walking stick, and a new silver nose to replace the hole that had been left as a souvenir

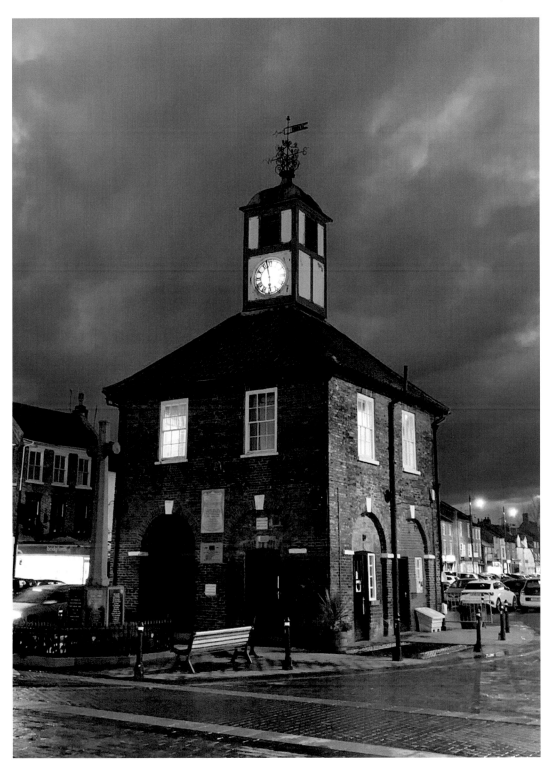

The tollbooth on Yarm High Street.

of his bravery. However, the two musket shots were still in his back and couldn't be removed, so he was sent back home a hero to retire on his handsome pension.

When he returned to Yarm, he opened a pub on the High Street where he lived until he died of natural causes in 1746. The pub stayed open until 1908 when it was converted into housing. A blue plaque now hangs on the wall of the houses for all to see.

Thomas was buried in the Yarm Churchyard and in 1968 the Queen's Own Hussars presented a headstone to commemorate his bravery.

So, if you happen to see the ghost with a silver nose near to his home on the High Street or if you see him looking at his headstone, rather than running in fright, just simply thank him for his service to King and Country.

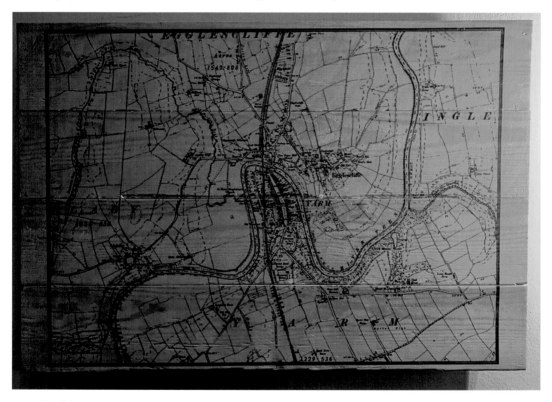

An old map of Yarm.

The Deserted Village of Embleton

As I have already said in the introduction, most of the ghost stories I relay are usually started by word of mouth. I then do a little bit of research on the location, before visiting the area where I'll talk to other locals to see what they have to say. I then will go and have a look around for myself.

This location was different. It would lead me to visiting one of the most eerie locations I have ever visited. I had been in Hartlepool looking around the Headland when I was talking to two ladies about the area. One of them said if I wanted to see a ghost then I should go to 'The Ghost Village'. I asked her what she meant, and she told me of a place where people see children running around the fields, men and women disappearing into thin air and people hearing the noises from a bustling village, but no one lives there.

Obviously, I was immediately interested and asked her what she meant by a ghost village? She explained that there was a village called Embleton about 5 miles west of Hartlepool near to Wynyard which was abandoned and is said to be very haunted and well worth a visit. Unfortunately, before I could ask her for any more information, her mobile phone rang, and the ladies had to leave as they were meeting someone for fish and chips. I thanked them for the information and told them that I hoped they enjoyed their lunch.

I was left a little confused as the only Embleton I had heard of was a small village in Northumberland near to Seahouses and I knew it was definitely not deserted. So, I started to do a bit of research on the internet and sure enough I did find reference of a village called Embleton, but it was listed as County Durham, yet the directions were classed as Stockton-on-Tees. This left me a little confused as to whether this village was Durham or Teesside. It was later in my research I realised that the village had been deserted in the sixteenth century when the area would have been classed as Durham but in today's boundaries it was classed as Wynyard and therefore belonged to Teesside.

As I read the history, I became enthralled by it. It first appears in 1190 as Elmedene, which suggests that it was originally an Anglo-Saxon settlement and could date as far back as the sixth century. The area then became a medieval settlement complete with a church, before falling victim of demesne in the Middle Ages, a law that would see hundreds of villages across Britain emptied and the land given to the lord of the manor for his own use.

It would appear that this small village would have had no inhabitants for over 500 years but some of the buildings were still standing, if only in ruins. I knew straight away I needed to visit 'The Ghost Village'.

I parked my car in Castle Dene Walkway car park and headed north for the forty-five-minute walk along the old railway tracks. During my walk, which was on a bright autumn day, I was surprised not to pass anybody. No dog walkers and people out for a wander. The only sign of life was a small farm I passed with some outbuildings. Then I arrived at Embleton.

I was taken aback by the sight as it looked like a film set from the latest horror movie. As I wandered around the earth mounds that had once been houses, I looked at the ruined church. The silence was very noticeable. No cars, no people and strangely no birdsong or natural noises of the countryside – it was a very eerie silence.

I was looking at the gravestones and started to head towards a small bridge that crosses Tinkers Brook when I heard a noise. It sounded like singing. The only way I can describe the sound is like the that of a television on low volume downstairs when you are upstairs. You can hear the sound but can't make out what's being said. It was very quiet and muffled but was definitely singing. I stopped and worked out that it seemed to be coming from the direction of the church. At first, I was curious to see what was making this noise, but as I got closer to the church my heart started

The approach to the lost village.

pounding and I was getting more anxious with every step. As I arrived at the church the sound stopped, and the silence returned. There was nothing or nobody in the church, but all of a sudden, all the hairs on my back and arms went up on end and fear started to take a grip as I had a sudden feeling of being watched. Not by someone in the church but from behind where I stood. I knew I had to turn around as it was the only route back to my car and I stood telling myself to move for what felt like an eternity, which in real time was probably only seconds.

I turned slowly but there was nobody there. I started to walk back the way I came, and my pace quickened as the feeling didn't subside. I felt as if someone watched me cross the fields until I was halfway back to the car. By then the sun had started to fade and I certainly did not want to be in the area in the dark.

Thinking back to my visit I constantly question what had happened. Could the noise have been natural coming from a car stereo or house, even though there weren't any nearby? Was it my mind playing tricks even though the area had been silent? Had I just scared myself with my imagination? I suppose I'll never know the answer.

I do know I need to return to Embleton, but I must admit it was probably one of the scariest outdoor locations I have visited and if I gain the courage to return, I won't be returning alone.

The church of Embleton village.

The Ship Inn, Saltburn-by-the Sea

When you visit this fabulous seaside town today, it is hard to believe the dark stories of its past. Tales of smugglers, illegal horse racing on the sands and many tales of the paranormal, including the apparition of 'The Smuggler King', are just part of its fascinating history.

Above the cliffs, you find the modern Saltburn that appeared during Victorian times, with all the grandeur of the huge buildings that are architecturally inspired by the era. The town was the brainchild of local businessman Henry Pease. Henry's family had become very rich and powerful Quakers in nearby Darlington, having become industrialists and owning major parts of the railway. Later they became important in the building and development of modern Middlesbrough.

It is said that Henry was walking along the clifftops when he had the vision of building a town above the cliffs where every house has a sea view, and the glen below would become the home of beautiful gardens for all to enjoy. After sharing his vision and after some negotiations, his family backed his idea and in 1860 Saltburn-by-the-Sea was founded.

Over the following decades the buildings were erected, all of them built with Pease brick. Every brick came from the family kilns and had the name stamped on them. The jewel in the crown would be the Zetland Hotel towering over the clifftop and overlooking the gardens below. The Zetland would also be one of the first hotels that had a private train platform and was recognised for its five-star views.

Also added to Saltburn during this time was a pleasure pier. Although pleasure piers were a common sight around the country, they were few and far between in the North East and this one is the only surviving one in the area today. The pier opened to the public in 1869 and it was reported that over 50,000 people visited in the first six months.

Just opposite the entrance to the pier you will find another fascinating example of Victorian engineering genius, 'The Saltburn Cliff Lift', also known as 'The Saltburn Inclined Tramway'. Originally Saltburn had a vertical cliff hoist, which was a lift to ferry visitors up and down the steep incline. However, in the early 1880s it was found that the wooden beams had started to rot, and it was deemed to be too dangerous. The lift was demolished and in 1884 the new replacement cliff lift was opened using a water balance system and twin aluminium cars. The lift is still open to this day and is still a major tourist attraction to Saltburn as it is the oldest working water balance system cliff lift in the UK.

I have mentioned a few of the notable landmarks of Victorian Saltburn as they all have tales of the same apparition. The spotting of this ghost was reported at the Zetland Hotel, before being seen in Valley Gardens. He then pops up again on the pier before being seen around the entrance of the cliff lift opposite to the pier. He is described as an older gentleman dressed in Victorian garb. Sometimes he is seen wearing a top hat; however, the people who see him without the hat always mention his thick white hair and say it looks like a judge's wig. He is said to always look happy, and the witnesses say that he doesn't look ghostly, just very out of place.

One person told me that they had seen the gentleman walking through the gardens and thought it was an actor re-enacting the period for the tourists, until he just disappeared. On returning home the person did a little research and found a picture of Henry Pease. They still swear to this day that this is who they saw that day in Valley Gardens.

At the foot of the cliffs on the seafront are the remains of Old Saltburn, a small hamlet dating back to medieval times, although archaeological finds have found that a settlement was in the area as far back as the Neolithic period.

The name Saltburn derives from the Anglo-Saxons and simply means salty stream, although when the Vikings arrived, they renamed the salty stream 'Skelton Beck'. However, Saltburn stuck and would be a hive of activity through medieval times up to the modern day.

Old Saltburn has one the most unusual buildings I have researched. Nestled on the seafront is a small white building. It has only one room and was a used as a mortuary. The mortuary was built in the late nineteenth century and was used to house the unfortunate souls that were washed up on the beach or had died of a sudden death. Surprisingly it was in use as late as the 1970s before being closed down. I have never had the opportunity to see inside the building, but it is said that it still has all of its fixtures and fittings from its grim working life.

With its history it is unsurprising that I have been told many tales surrounding the old mortuary. There have been reports of crying and wailing coming from inside. Lights have been seen coming from inside when the building is locked up. Apparitions of both men and women have been seen walking in and out of the closed and locked doorway. However, the creepiest tale I was told was of a young girl who sits at the door hugging her knees. She is dressed in a soaking wet dress and has long blond hair; she sits crying and clearly in distress. But when you approach her, she simply disappears except for a pool of seawater on the ground where she had sat. No one knows who she is or what her story is.

The oldest building still standing is The Ship Inn. The Ship dates back to the sixteenth century and has served the locals their ales for nearly 400 years. Nestled on the beach and surrounded by the cliffs and the glen, the pub would also become the hub for smugglers. Smuggling would be a central part of Old Saltburn's economy in the eighteenth and nineteenth centuries and the inlet surrounded by the glen made the hamlet ideal for contraband to be smuggled ashore.

Ghostly figures are often reported at night time scamping across the beach carrying casks and barrels, only to disappear as they run up to The Ship Inn. There has even been a small tradition sloop repeatedly sighted off the coast opposite the pub that is only seen during storms of thunder and lightning.

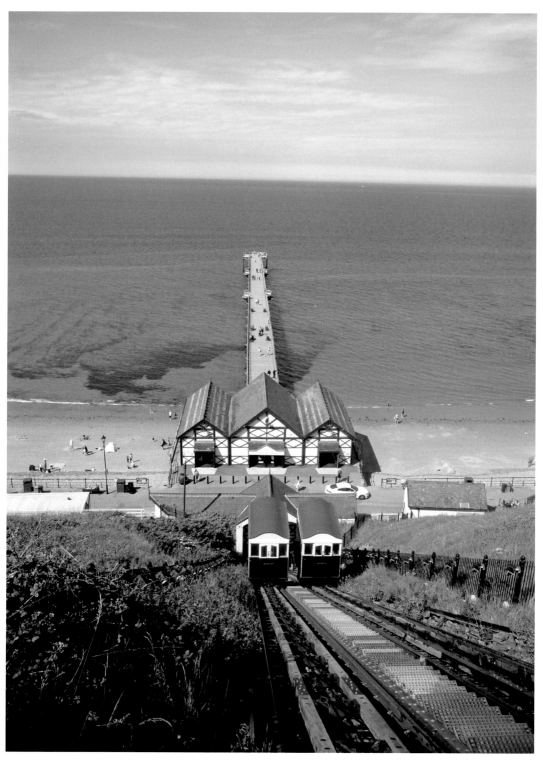

The clifftop lift of Saltburn-by-the-Sea.

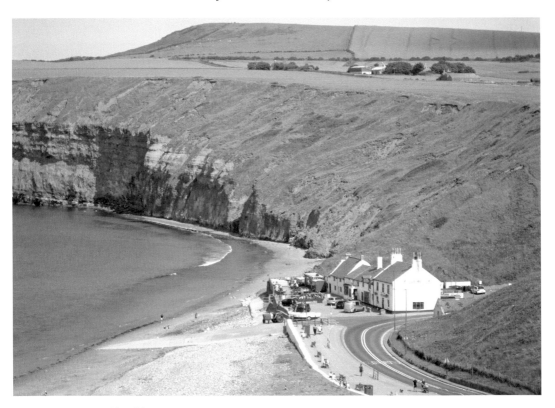

A view over old Saltburn.

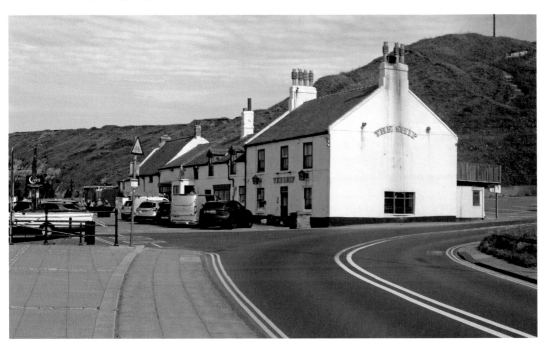

The Ship Inn.

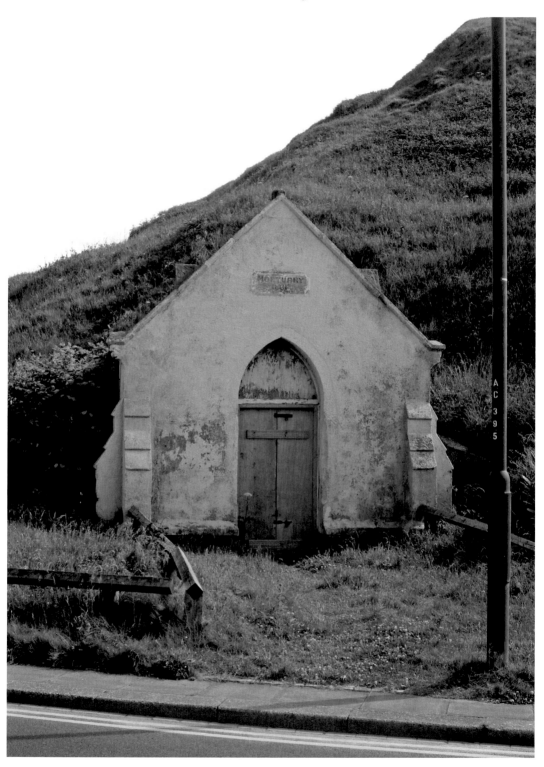

The unusual old mortuary.

Inside the pub there are tales of glasses smashing, chairs moving, and tables being tipped over on their own. Staff have reported seeing dark shadows of men moving around the pub when 'last orders' have been called and the doors have been locked up for the night.

The most reported apparition is the sighting of a man that walks the pub both inside and out. He is dressed in clothes from the Georgian era, with tight white breeches and a very dapper dark coat. He is said to walk tall and very proud only to disappear through the walls and doors of the pub.

The ghost is believed to be that of John Andrew, the 'King of the Smugglers'. John Andrew was a Scotsman who became the landlord of The Ship Inn after his marriage to a local girl called Anne Harrison. As the landlord he created a band of brothers and started the highly profitable art of smuggling. Along with the riches of this illicit trade came power as he started to buy the local land and became one of the gentry. Ironically, he was recruited by the customs officers to help catch the smugglers. The customs officers had not realised that John was the main culprit they were trying to stop.

It becomes a grey area of history as to how John Andrew died. It was reported he was caught and hanged in Hornsea in the late 1820s, although this is now said to be his son. Indeed, his grave is said to be in the corner of All Saints Church in Saltburn and that he died in 1844.

One thing that is not disputed is that his fortune was never recovered and is said to still be hidden in the secret tunnels that lie within the cliffs of Saltburn. So, if you ever see the ghost of the King of the Smugglers, be sure to ask where it is.

Rushpool Hall, Saltburn-by-the-Sea

Only a few moments' drive from Saltburn's seafront, hiding at the western end of the glen and Valley Gardens, you will find one the most beautiful and fantastic examples of Victorian Gothic architecture that you will ever see.

Rushpool Hall was built in 1864 for a local businessman and entrepreneur called John Bell. It cost a whopping £100,000, which is around £13 million in today's money. John had earned his fortune as part of the Bell Brothers Iron Company, who had pioneered iron manufacturing and owned all the local ironworks.

Saltburn was still known as Skelton in this era and the Bell brothers had sunk mines in the area and the riches poured through the Skelton mine shafts. Indeed, the hall was built with the first ironstone produced from the Skelton shaft.

John would live with his family in Rushpool Hall until 1881. The family then moved to Algiers and only frequented the hall during the summer months. John Bell passed away in 1888 in Algiers. After John died the hall was leased by another local businessman and steel pioneer, Sir Arthur Dorman. Sir Arthur would become a hugely prominent figure across Teesside as his companies would employ tens of thousands of the local men and women. He stayed at Rushpool until he bought Grey Tower in the nearby village of Nunthorpe, and the Bell family returned in the shape of Mary Bell, John's widow, and their daughter Sybil.

The hall changed hands again 1906, when Sir Joseph Walton took ownership. Sir Joseph was the owner of coal mines and lived in Rushpool until his death in 1923. Over the past century, Rushpool Hall has changed hands on several occasions and had several different usages. It was a boarding school, events venue and has now been lovingly restored to serve as a luxury hotel.

As with all country homes, Rushpool Hall has many ghost stories. It boasts that a grey lady wanders around the corridors. There have also been reports of a nun that stares through the windows from outside. However, there are a couple of strange events that happened that could give explanations to other ghosts that have been seen.

It was reported that lights would flicker and go out in the centre of the hall for no reason. The owners had called out some local electricians to check the wiring as the lights would switch back on in the middle of the night. None of the tradesmen could find any faults with the electrics but replaced everything on more than one occasion on the insistence of the owners. However, the problem still persisted. A few years later visitors started to report seeing a maid wandering the corridors before the lights went out. The owners obviously knew they had no maids that worked in the hall at the time, leaving them baffled by the events.

However, in 1904 the hall suffered a great fire that destroyed it. It is reported that one of the hall's maids left a candle unsupervised and a draft blew a curtain onto the naked flame. Within minutes the house was up in flames. A battle ensued with the local fire brigade, but unfortunately within hours the hall was left a burnt-out shell as the roof collapsed.

Was the maid spotted in the corridors the ghost of the maid that left the candle? Was she switching off the lights, not understanding the modern technology of electric as she didn't want to repeat the fire she once caused?

A story of a lady that wanders around the surrounding gardens and woodland has been told many times. This story is different from the ones above about the grey lady and nun. This lady is often spotted late at night and is seen when visitors' car headlights cross the front lawn, or she is seen running across the small lane that takes you from the main road to the hall. She is dressed in a white gown and seems to be running away from the hall, but when the eyewitnesses search further, no one is found.

Could it be the spirit of the mysterious Margaret Bell? Margaret was the first wife of John Bell. It was recorded in 1861 that John and Margaret were married with children. Unusually, John is listed as living in Newcastle, but Margaret is registered as living in South Shields. However, in 1865, the year Rushpool Hall was completed, Mary vanishes without a trace. She disappears from all records and is not mentioned again. Theories over the years include that she was not of sound mind and was moved away from the area. Some say that John didn't love her anymore and she ran away with a broken heart, and some theories have a darker ending.

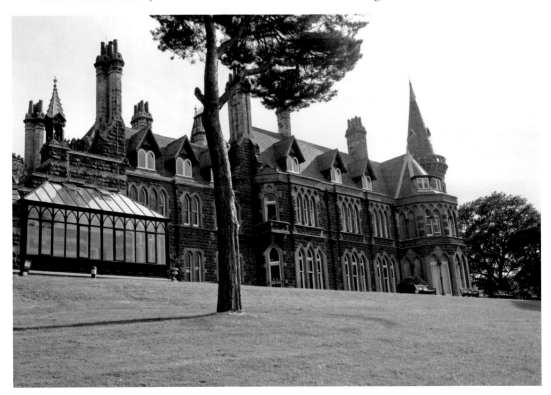

The beautiful architecture of Rushpool Hall.

The grounds where there have been many sightings of ghosts.

St Germain's Cemetery, Marske-by-the-Sea

Sitting 2 miles south of Redcar and only a couple miles from Saltburn is the picturesque village of Marske-by-the-Sea. Marske's history dates back over 800 years and its name is said to originate in the eleventh century.

Over the centuries, the villagers would have made a living from the sea and the land. Fishing and farming was popular in the area, and it is not until the seventeenth century that we see the village growing towards what we can see today.

The village is not mentioned very often in the history books until 1625 when local landowner William Pennyman built Marske Hall on the outskirts of the village. After this we see numerous buildings and houses pop up around the centre of the village as Marske started to grow.

During the eighteenth and nineteenth centuries, Marske became popular with smugglers. It was ideally located with its beach surrounded by dunes that rolled back to the isolated countryside. Like their neighbours in Saltburn, the locals would be involved and Marske was known for its illicit trade in tea.

During the centuries that followed, Marske benefitted from the growth of Middlesbrough and Redcar with a majority of its residents now working in the various industries in larger towns.

One of the oldest areas of Marske is at St Germain's Church and cemetery. It sits on top of the headland and looks out over the beach and the North Sea. The church dates back to Norman times, although the tower that we see standing now was rebuilt in the 1820s. The church that surrounded the tower was demolished in 1956 as the church had been replaced by St Mark's in 1867 and as it had little use it had become too expensive to repair. Notably the bell from the tower of St Germain's was moved to the new church as it was over 500 years old, and the local parish wanted to give it a new life.

The cemetery or churchyard runs alongside the clifftops and was used to bury sailors who came to a tragic end as their ships and boats hit the rocks below, as well as the local people including the prosperous family of the Zetlands, who have a crypt beneath the church, and is the last resting place of the father of Captain James Cook.

Obviously, a graveyard is always going to play host to many a ghost story and St Germain's is no different. Reports of dead sailors roaming around the gravestones and sightings of dark figures moving near the tower are rife. People have reported hearing the bell ringing in the middle of the night even though it was removed many years ago.

The story that I was told personally was of smugglers that are seen running across the cemetery. It is said that on nights when the moon lights up the church and the dunes running down to the beach, people have seen a small group of men charging towards the shoreline carrying boxes and rolling barrels. The men are silent and seem oblivious to the surrounding modern-day housing estate. They move down the path onto the beach and vanish into the sea.

They are believed to be the smugglers of days gone by using nightfall to cover their unlawful activities and it brings into question the rumours that the old church of St Germain's was used as a hiding hole as the customs officers would never ask the local clergy if they could search the house of God.

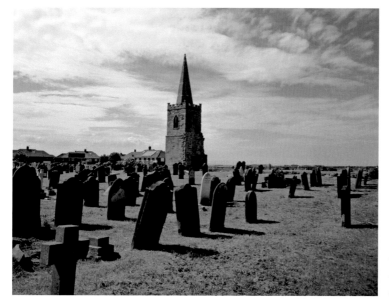

The surviving tower of the original church.

A path to the beach where sightings of smugglers have been reported.

Kirkleatham Museum

Kirkleatham is a small village that lies 8 miles to the east of Middlesbrough's town centre. We know that there's been a settlement here since Norse times as the word 'kirk' was Viking for church. The village does feature in writings from the eleventh century before the village took shape in the seventeenth century when it became the estate of the Turner family. The Turner family bought the estate in 1624 and generations of the family would shape the village and build most of the impressive buildings that can still be found standing.

Sir William Turner, who was born and then christened in Kirkleatham Church, built the Kirkleatham Hospital in the village. The Sir William Turner Hospital was in fact an almshouse for the poor. The hospital was rebuilt and extended in 1742 and has remained open ever since. Today it is an independent retirement home.

Sir William died in 1693. He died a single man with no children and bequeathed most of his estate to his nephew Cholmley Turner, with the promise that he would continue his work in Kirkleatham. Cholmley kept this promise and in 1709 he opened Kirkleatham Free School. The school would become a boarding school for boys before becoming the Kirkleatham Old Hall Museum that we see today.

Another building of note in the village that was built by Cholmley Turner is the magnificent mausoleum in the grounds of St Cuthbert's Church. A church has stood there since the nineteenth century and Cholmley built the mausoleum in memory of his son. He later rebuilt the church and attached the new building to the last resting place of his child.

When I visited Kirkleatham and spoke to people about its ghost stories, I must admit to being surprised that I heard of no stories surrounding the church or graveyard. It is usually the first place I'm told to visit. Instead, I was told to visit the museum as the Old Hall has many.

The Old Hall began its life as a school for the local gentry to send their boys for an education. It was never a successful enterprise as none of the Turners took a great interest in it. But it still educated the locals until 1869, when the school was relocated to Redcar. The building would stand almost empty for the following 100 years, only being briefly used in First World War as a hospital for wounded soldiers returning from the front lines of Europe. In 1981, the hall would find a new lease of life as the Kirkleatham Museum. It is still open today with a fine array of exhibitions.

I was told several stories about the hall and the surrounding woods. The sightings of young boys running around in school uniform are rife, but then this is totally understandable as it was a school. The sounds of running feet and chimes of a bell ringing are also often reported around the hall as most of the stories relate to its schooling history.

Some sightings are of soldiers hobbling around the corridors and on the grounds outside. The moaning sounds of men in pain have also been reported in the area. Again, are understandable due its use during the First World War.

However, the story of the beautiful Lady in Red is probably the most intriguing. The reports have only come to the fore in the past ten or twenty years and all include the sighting of a lady wearing a red dress and a long white headdress. She is described as having a beautiful face and long ginger hair. She has been seen not only in the hall, but also floating across the front lawns. It is said that she appears from the fields opposite the building and comes over the road and through the grounds, before disappearing into the hall. She is silent and seems oblivious to her surroundings. At first no one had an explanation. Could it be one of the Turner family returning to the village? Could be Lady Teresa Newcomen, who would work tirelessly at Kirkleatham in the 1800s?

But it became clear as an exhibition was completed in the museum. Part of the building has a display with artefacts from the Street House Anglo-Saxon Cemetery that was found in the nearby town of Loftus. Part of the relics on display include the jewellery of a buried Anglo-Saxon princess. Could this beautiful Lady in Red be our very own princess being drawn to Kirkleatham to be reunited with her earthly treasures?

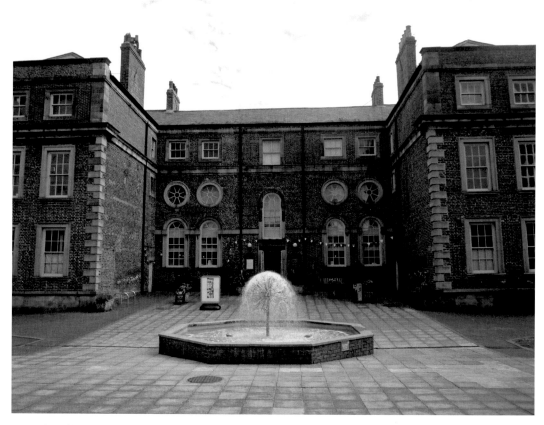

The old school.

One of exhibitions of the museum.

Plaque above the school's door.

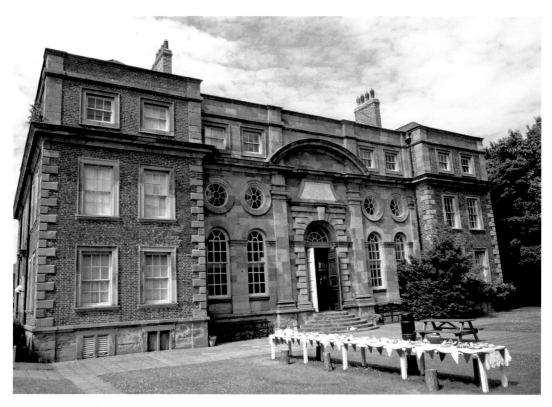

The front of the school.

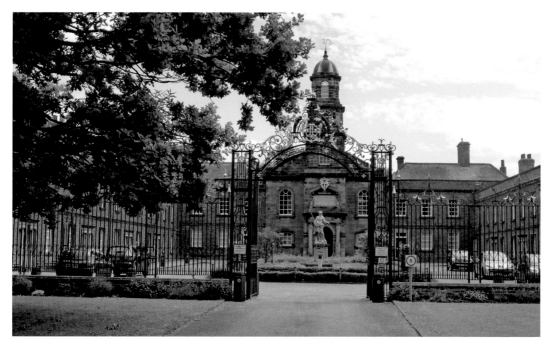

Kirkleatham Almshouse.

The Monks of Guisborough

When I first visited Guisborough, I don't know what impressed me the most. Was it how beautiful this quaint little town was? Or the massive amount of history that is centred within its small surroundings?

Since I was a teenager, I had heard of Guisborough and its many ghost stories. I had heard of the monks that roam the village, and the haunted school and its many haunted pubs. Obviously, as I got older and I could drive, Guisborough was one of the first 'drive outs' I did, and the town did not disappoint.

The origins of Guisborough start in Viking times. It is believed the town's name originates from the Viking landowner, although this is speculation. Then in the twelfth century, the priory was built. Originally named the Priory of St Mary, it was built by the Normans and would become one of the richest monasteries in the country. As it was built on the instruction of the powerful and rich Robert de Brus, the priory was to be given many gifts from the Crown, as well as receiving money from many of the De Brus family line. Robert de Brus is not to be confused with the Scottish king Robert the Bruce, although they were related.

The priory would continue to be successful until Henry VIII ordered the Dissolution of the Monasteries in 1538. After that the priory would lie empty and continue to rot away until it became ruinous. The remains that we see today still allow us to appreciate the grandeur of the building and the enormous amount of money that would have been needed to fund it.

Next to the priory you will find another of Guisborough's historic holy buildings, as here stands St Nicholas' Church and graveyard. It is believed that a church has been attached to the priory since the end of the thirteenth century. However, the tower that we see today dates to the sixteenth century. The church continues serving the town to this day, with several alterations taking place at the start of the twentieth century. Inside the church you will find the beautiful and intriguing De Brus Cenotaph. The cenotaph is worth a visit to Guisborough alone.

As you can see, Guisborough has a rich past and still enjoys its popularity today with both residents and visitors and has all the ingredients to be a very haunted town.

The first ghost stories I was told were about the monks that are seen all around the priory and beyond. There have been many reports of apparitions seen in the grounds of the ruins and the paths that surround it. People have reported hearing chanting coming from the area late at night, but no one is to be seen when the sounds are investigated. There are reports from many witnesses that have seen a monk dressed in a hooded habit opening a door on the east wall. I spoke to a gentleman who told me he had been walking down the High Street and something caught his eye. He said he

Guisborough Priory.

remembered it was a full moon as the sky was clear of any clouds. In his own words he told me:

> I saw someone open a door or a gate and look around. I knew there was no doorway as there is very little of the wall left, however I kept staring as I was trying to make sense of what I was watching. A monk then appeared and looked around again as if he was making sure he wasn't being watched. He then scurried away down the wall and disappeared into the night.
>
> It took me a few minutes to regain my composure before crossing the road and stood at the place I had just seen a door. There was nothing there, nothing at all.
>
> Over the following days, I shared my story with a few family and friends, but they just looked at me as if I was mad, with one or two of them questioning me on my alcohol intake that night. I haven't told the story for many years now as I know it sounds unbelievable, but you know what? I know what I saw!

The gentleman's story replicates many reports about the area, and it is believed to be the spirit of a monk who was sneaking off for a night out with the local ladies.

Next to the priory you will find Prior Pursglove College. The building was originally opened in 1561 as a free school and almshouse by the Prior of Guisborough Robert

Entrance where a monk was seen.

Blue plaque of the grammar school.

Pursglove. For over 400 years the site has been used for educational purposes, becoming a grammar school in 1881, then changing to a college in the 1970s, before finally becoming a sixth-form college.

The reports of paranormal activity within its walls and grounds are rife, with reports of monks that still roam the site including the lane that runs between college and graveyard. Poltergeist activity was reported inside the building, with furniture being thrown around and doors slamming shut. The activity points to someone or something being extremely angry in the area.

I have heard two explanations for the activity. The first is that a former headmaster hanged himself in the building at the start of the twentieth century and still roams the corridors and classrooms not realising that time has moved on and that the rules today are more relaxed than when he was in charge. The second reason is that it is the spirit of a monk or monks that are angry that they had to leave their home with the arrival of King Henry VIII's men and the ruinous state that their beloved priory opposite has become.

Whatever the reason, I must admit I walked down the tree-covered lane alongside the graveyard a lot quicker than I might have done otherwise.

The old school.

One of the haunted pathways around the graveyard.

The Mucky Duck, Guisborough

Just a short walk down Church Street and on to Westgate you will come across a wine bar and restaurant called Cookfella's. However, when you look past the newly painted walls and beautifully presented interior you will find a building with a historic past and a resident ghost.

We know by reading the informative signage on the side of the building that today's Cookfella's was once known as The Black Swan. First mentioned in 1823, the pub became known by the locals as The Mucky Duck and was run by a landlord called John Husband.

At the rear of the pub you will find a modernised terrace that once was an attached stable area, suggesting that the pub welcomed travellers and probably ran as a hotel during market days or the fairs that took place in the town.

Over the past 200 years, the landlords have changed, patrons have come and gone, and even the name has changed. However, one thing that has continued is the reports of the building's resident ghost. The ghost of an old lady has been reported time and time again by both landlords, staff, and guests. She is described as being dressed in period clothing with some saying she is wearing a shawl. The witnesses say she walks from the back of the building and goes to look out of the front windows. She stands there for a few seconds looking out across the road and then disappears. She has also been seen from outside. A report said that someone saw someone in the bar looking out when the pub was shut. They alerted the landlord thinking it was burglars, but no one was present when he arrived.

Another story I was told was of a young boy seen in the terraced area at the back. He is dressed in Victorian clothes and walks back and forth between the walls as if he is still feeding the horses that once would have been present. Again, like his counterpart in the bar, he simply disappears as fast as he is spotted.

Guisborough enjoyed a vibrant and affluent time throughout the Victorian era and The Black Swan would be just one of seventeen inns in the town, but you can see the success of the town as Gisborough Hall was added to its landscape. The hall was originally called 'Longhull' and was built by Admiral Thomas Chaloner in 1856. His family had owned the estate for more than 300 years as it was bought from King Henry VIII in 1570 by the Admiral's namesake Sir Thomas Chaloner.

I haven't misspelled Gisborough Hall; the Chaloner family decided they preferred the ancient spelling of the town.

After the Admiral's death the estate passed to Richard Walmesley. Richard extended the hall at the start of the twentieth century, and it was his family's residence until the Second World War. After the war it became a retirement home until the 1970s. Today, the hall still stands in all of its glory and is now a luxury hotel.

There are numerous reports of paranormal activity at the hall. The staff have reported an elderly lady that is spotted walking around the corridors of the hotel. When they ask her if she needs any help, she ignores them and disappears at the end of the corridor. In the same part of the hotel is a report of an old gentleman that salutes you when he sees you. He doesn't speak and also disappears at the end of the corridor. Could these be souls that still visit the hall from when it was a retirement home?

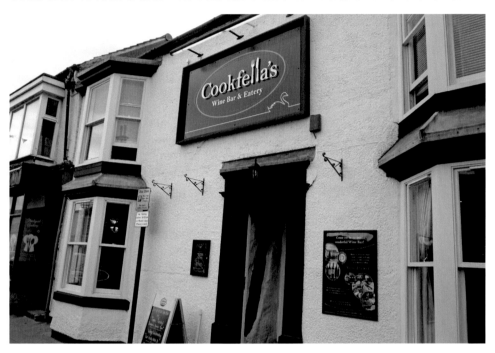

Cookfella's originally The Black Swan.

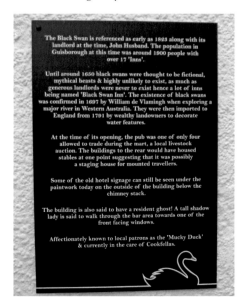

The sign telling the history of the pub.

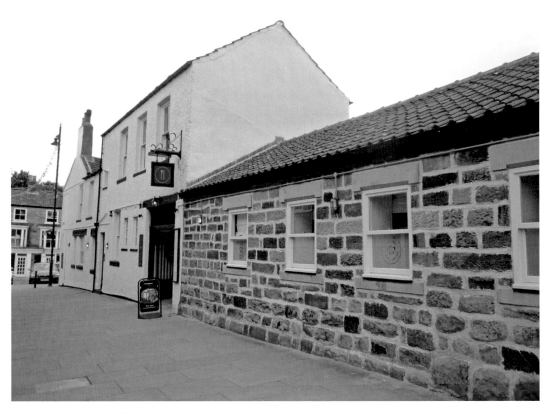

The original stables.

The River Leven Lovers, Great Ayton

Only a few minutes' drive from the hustle and bustle of Middlesborough town centre you will find the tranquil and quiet village of Great Ayton. I found this hidden treasure as I researched Captain Cook's life as he spent some of his childhood in Great Ayton after moving there from the nearby village of Marton.

The village has a long history. It began as an Anglo-Saxon settlement and the name is Norse for river farm or farm by the river, so it is feasible that the settlement was visited by the Vikings as the River Leven runs through the centre of the village. The village continued to appear in the history books over the centuries including in the Domesday Book, then later in the thirteenth century it is mentioned that the landowners gave permission to travelling monks to stop and let their horses drink from the river.

Great Ayton would develop many industries in its vicinity. It had a mill on the river which led to weaving. The quarries of the surrounding Cleveland Hills also led to the mining of ironstone becoming prominent in the eighteenth and nineteenth centuries. The village suffered in the modern era along with the rest of Teesside as all of its industries closed. Now the village is very popular with tourists and is a much sought-after residence for commuters who work in Middlesbrough and the returning businesses in Teesside.

One of the ghost stories takes place in the Low Green area of Great Ayton where you will find the old Ayton Hall next to the twelfth-century All Saints Church.

The daughter of the wealthy owner of Ayton Hall fell in love with one of the workers from the corn mill on the opposite side of the river. Knowing that her father would never approve of her relationship with a commoner, the two lovers would meet on the bridge late at night. As time passed their love for each other grew, but as she was getting older her father had started to talk about a choice of husband for her. Her father was looking at the local gentry and the wealthy families of Teesside to find someone suitable to join his family and take the hand of his precious daughter.

However, every time he introduced a new suitor to his daughter, she found fault and refused to entertain the idea of marriage. Knowing that her father was losing patience with her, and she was starting to run out of excuses, she met with her lover and discussed what they could do to continue their love affair. The first idea was to come clean and tell her father and introduce him to the love of her life. However, the miller ruled this out as he knew her family would never except it. So, they decided to run away together. He was a skilled miller and could find work elsewhere in the

country where they could get married and raise a family without any fears from her family. The couple planned to leave under the light of the next full moon.

Unbeknown to the couple, her father had been watching the pair over the past few weeks as he had become suspicious of his daughter's behaviour but was undecided what to do next. He didn't want his daughter to marry beneath her but knew if he interfered, he risked losing her.

The night of the new moon arrived and the daughter started to pack a small bag of belongings when her father entered her room. Startled, she stood frozen to the spot and as her father looked at the bag, his face turned red with rage. He grabbed her bag and an argument ensued. She tried several times to get past him before he locked her in her room. In a fit of rage her father stormed out of the hall and across his estate to the bridge.

The miller didn't see him coming until it was too late. The father killed the miller with a single blow to his head. The miller's limp body fell into the stream below and the blood from his head wound turned the water red. As the father stood staring at the body below in shock at what he had done, he saw his daughter running towards him from the hall. After he had locked her in, she had climbed out of her window as she had done many times before to meet her lover. The father ran to her and stopped her in her tracks and told her there had been a tragic accident and her lover had slipped and fell to his death. Knowing that he was lying, she turned screaming and ran back to the hall.

The River Leven where the river runs red.

The entrance to Ayton Hall.

The murder was covered up and the story of the miller falling into the river became accepted, probably costing the father a good few quid in pay-offs. The body was quickly buried in an unmarked grave in All Saints Church graveyard and the events of the fateful night were never discussed again. It was said that the daughter never spoke a word until the day she died of a broken heart.

It is reported that if you are near the river and its crossing on the night of the new moon, sometimes the river flows red. And if you see the red river, you need to look towards Ayton Hall and you will see the figure of a ghostly girl running towards you. The apparition of the ghostly girl is also spotted in the graveyard of All Saints Church. She is on her knees sobbing into her hands. It is believed she is crying over the unmarked grave of her lover.

There are very few facts to be found about this story. No names or dates are ever mentioned. You will have to visit Great Ayton and see if you spot the river turning red to decide whether there is any truth to the legend.

The eleventh-century church.

Wilton Castle, Wilton

You will find Wilton village nestled at the foot of the Eston Hills, opposite the Lazenby area of Middlesbrough, and it is a real hidden gem of Teesside. This small village is home to Wilton Castle, and what a fantastic history it has.

The original Wilton Castle was built in Norman times and started as a wooden manor house by John de Bulmer, the then lord of the manor of Wilton. The Bulmer family would become synonymous with the castle for the next 500 years and their rebellious nature would end in execution.

By 1330 the manor house had been passed down through the family and was now owned by Sir Ralph de Bulmer. Sir Ralph was granted the right to fortify his house with stone by King Edward III, known as 'a licence to crenelate', which meant that his manor house would now become a castle. The work was completed and the castle spent the next 200 years in the hands of the family, being passed through the generations until 1537.

In this time period, England was in turmoil due to Henry VIII's desire to marry Anne Boleyn, and within a year he had turned his back on the Catholic Church and had established the Church of England and declared Britain free from the rule of Rome and the Papacy. This was followed by the Dissolution of the Monasteries and left a lot of his people feeling angry and dismayed.

The owners of Wilton Castle at this time were Sir John Bulmer and his wife Lady Margaret, and they fell into the angry and dismayed camp. Sir John and Lady Margaret became involved in the Pilgrimage of Grace, a revolt led by the north against King Henry VIII that was intended to give back the land and monasteries to the monks and nuns that were being violently evicted.

Unfortunately for the Bulmers, the revolt was unsuccessful and those who were involved were executed for High Treason. Sir John was hanged, drawn and quartered at Tyburn in 1537 and Lady Margaret was burned at the stake at the same time in London. Their estate and titles were stripped from the family.

In 1547, the castle returned to the Bulmer family. Sir Ralph Bulmer was the nephew of Sir John and Lady Margaret. Sir Ralph had a successful military career as soldier during the Border Wars. He was knighted for his service by King Edward VI, who also rewarded him by returning Wilton Castle and the estate back to the Bulmer family. However, this was not going to last for long as only eleven years later in 1558 Queen Mary would take away the estate from the Bulmers and give it to one of her politicians, Thomas Cornwallis.

Over the next 250 years, Wilton Castle would pass through many hands as the estate was sold every time it was bequeathed to a new generation. Then finally at

the start of the nineteenth century, the estate was bought by Sir John Lowther, 1st Baronet of Swillington. Sir John demolished the old castle as the lack of attention by the previous list of owners had left the building ruinous and uninhabitable. By 1810 the castle had been replaced with the impressive Gothic-style manor house. Over the following years, the house would see numerous improvements and expansions until it became the building we see today.

Wilton Castle would remain with the Lowther family until the end of the Second World War when the owner, Colonel John Lowther, decided to sell the estate. In 1945, ICI, the large chemical company who owned numerous chemical plants in Teesside, bought the castle and converted it into an office for their company.

By 1970 most of the office workers had moved to new offices around the area and the castle's interior was revamped and reopened as a hotel and golf course. Finally in 2001, the golf course was sold off to its members and Wilton Castle was converted into private luxury apartments.

There have been many stories and reports of the paranormal surrounding the castle and grounds. Most concern the Bulmer family and the tragedies that marred their bloodline. Reports of a lady seen both inside and outside walking around with a dog by her side are often made. However, I think this story is getting confused with a very similar story at Wilton Castle in Ireland, which has no connection to its Teesside namesake, or it could very well be coincidence that they have the same type of haunting.

My favourite story of Wilton Castle is one about a 'Flaming Lady'. She has always been sighted in the grounds of the castle. Back in the 1960s, before the land in front of the castle was a golf course it was rolling fields and woodland. One night the security of the ICI offices saw a fire in the woods. Panicking that if it got out of control it would spread and create a real danger to the building, they ran out into the woods to see if they could extinguish it themselves. As they ran towards it, it seemed to move several times. As they arrived at the spot they thought was on fire, they found nothing. There was no fire, no smoke, not even a scorch mark on the ground. This continued for several minutes at different spots in the woods before finally they seemed to get close to the source out in the open fields. However, what they saw next was going to terrify them. The fire or flames were coming from a lady walking up towards the castle. She wore a long blue dress and was described as looking like she had just come from the court of Henry VIII.

By now the security guards were shouting at the woman as they feared for her life. But as she arrived at the front drive of the castle, she disappeared. The flames and the fire vanished with her. The guards spent all night looking for her or any signs of fire damage in and around the castle, but found nothing.

The Flaming Lady would be spotted many times after that and later she was spotted moving across the newly built golf course. I'm not sure when the witness that reported this sighting worked at the golf course, but he reported that it was dusk on a warm summer's evening. He had been locking up and was checking the grounds to ensure that all the golf club members had left, when across the course he could see a fire. He quickly made his way across knowing the damage of fire to his fairways and greens would be costly. As he arrived, the flames seemed to move. He stood and watched as the flame moved two or three times before letting out a scream as out of the woods a woman walked towards the castle.

He described seeing a lady whose long blue dress was on fire. As he ran towards her to help, she vanished into thin air along with the blaze. Just like the security guards in the earlier story, he looked around and there was no sign of a fire ever taking place. The fairway was still in perfect condition with no hint that a fire-engulfed woman had just walked across it.

Although Lady Margaret Bulmer was put to death 200 miles away in London, could the Flaming Lady be her spirit returning to the home she loved before she was burned at the stake?

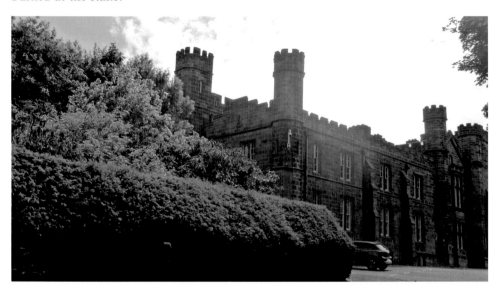

Wilton Castle.

The woodlands where the 'Flaming Lady' has been spotted.

The Witches of Roseberry Topping

Through my interest in the paranormal and local history, I have found researching the stories of witches fascinating. I struggle to believe that we were still hanging people for witchcraft less than 300 years ago, but such was the fear that was created throughout the country.

What I did find surprising was the lack of stories within Teesside of witches and witchcraft. It could well be that as the area was made up of smaller villages, the hysteria never found its way into the area, or it wasn't documented. However, I did come across a couple of stories. The first is said to have occurred at Roseberry Topping.

No matter from which direction you are travelling to Teesside you will see Roseberry Topping rising up from the Cleveland Hills and towering over the many villages below. Also known as the 'Mini Matterhorn' due to its distinctive peak, it has been the focus of settlements for thousands of years dating back to the Bronze Age.

Its's unusual name is believed to derive from the Vikings. It is first mentioned in 1119 and is referred to as 'Othenesberg', which translates to 'Odin's Rock'. Odin was a Norse god, and it is said that he is the overseer of Valhalla (the hall of the death). And as any Marvel fan will know, he was the father of Thor and adopted father of Loki.

Obviously, due to its original name there are many stories surrounding the mysteries of the hill. Over the following centuries, the name changed with local dialect until 'Othenesberg' became 'Roseberry' and Topping was added from the Yorkshire word 'topp', which simply means top of a hill, and it is the top of the hill that makes it so distinctive. The jagged peak was formed in the early 1900s when a mine shaft collapsed within the hill and caused a landslide on the side of its peak, leaving behind its hooked appearance and the likeness to the Matterhorn in Switzerland. Roseberry Topping even has its own rhyme said by the locals to predict bad weather: 'When Roseberry Topping wears a cap, let Cleveland then beware of the clap'. The hill is now in the hands of the National Trust and is visited by thousands of walkers and sightseers who climb to its peak for the best views across the whole of Teesside and beyond.

The stories of the witch and witches of Roseberry Topping are very similar to stories I have been told from all across the country and seem to follow the same pattern. Witches are said to be able to change their appearance into animals. Now everyone tends to think of cats straight away when talking about witches, but the cat is said to

be the witch's familiar or friend. A witch will turn herself into a smaller creature and the witch of Roseberry Topping could turn herself into a hare.

One night she was on the hill practising her witchcraft when a hunting party from the nearby village of Newton approached. Knowing that if they caught her practising her craft they would kill her, she shape-shifted into a hare and started to run away down the banks of Roseberry Topping.

Unfortunately, the hounds of the hunting party caught the scent of the hare and give chase. One hound bit at her leg drawing blood from it, but she managed to avoid the full capture of its jaws and run through a small hole in the wall of her wooden cabin before shifting back to her natural form.

As she started to bathe the wound there was knocking on the door. The hunting party had followed the trail of blood. She answered the door and tried to hide her injuries, but the men could see the blood pouring from her leg and immediately started to shout 'Witch!'. She was bound and gagged and marched up the banks of Roseberry Topping and burned at the stake. As she burnt to death, she cursed the men and said that she would stay on the hill forever.

Since then, there have been reports of people seeing a witch wandering around the misty peak of Roseberry Topping under the moonlight and reports of people seeing a wounded hare that limps around the pathways down to the village below.

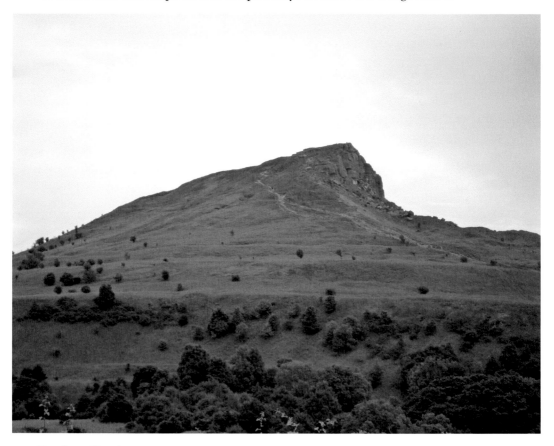

Roseberry Topping.

The other ghost of a witch that has been seen around Roseberry Topping is that of Peggy Flounders. Peggy lived in nearby Marske-by-the-sea and was branded a witch all her life. Fortunately for Peggy, she lived in the nineteenth century and long gone were the days of the witch trials where she would have been executed for such claims. Peggy had spent all her life being ridiculed and accused of being a witch due to her appearance, which was said to be strange, and as she grew older, she grew a beard that most men would have been envious of. In her later days it is said that her attitude towards people turned nasty and she would use the claims of being a witch to scare the local children.

Local farmers would blame her for everything, from a poor crop to their animals dying, saying she had cursed the land. The local fisherman used her as a scapegoat for any boat that sank and a poor catch in their nets.

Other rumours were that Peggy would visit Roseberry Topping along with her black cat on the nights of a full moon to use its rays to charge her witching equipment including her broomstick and cauldron. Others said she visited the hill to cast her curses on the villagers of Marske.

Peggy died at the ripe old age of eighty-five and ironically was given a full Christian funeral and is buried in the cemetery of St Germain's Church in Marske.

Many people have said they have seen the ghost of Peggy on the hill. They have seen a little old woman walking the paths between Marske and Roseberry Topping dressed in a black hooded cape with a cat in tow. But they run away as she looks up and they see the face of a bearded lady and she starts laughing in a loud crackling shriek.

The many pathways at the foot of the hill.

Conclusion

Well guys that is your paranormal trip around Middlesbrough and Teesside. I hope you have enjoyed reading about the vast history of the area and its ghostly goings-on. I have tried to include some of the lesser-known stories of the area and looked at the history you yourself can visit.

I love the North East, from Seahouses to Saltburn, and from the beautiful coastline to the many hills and countryside that surround our region. I am proud to tell people where I come from and have spent endless hours telling them of all the beauty of the North East, including the castles and how we led the world during the Industrial Revolution. I boast about the people and how friendly we are and how resilient a region we have become.

The Romans, Vikings and Normans all invaded us and loved the area so much that they built their own settlements and left their mark in our history.

There are so many places to visit on our own doorstep that one book cannot cover them all, so please get out there and look around for yourself. Go and discover the old castle ruins and wander around the monasteries and priories. Stop for a pint at one of the many old coaching inns or have a stroll down the old high streets and enjoy our heritage.

One more thing to remember when you are walking around is to keep your eyes peeled and to look into the windows or through the trees, as you never know who or what you will see.

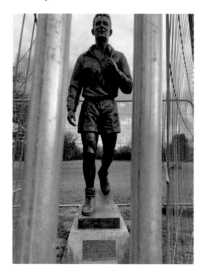

The statue of the late, great Brian Clough.